OXFORD

A POTTED HISTORY

DAVID MEARA

AMBERLEY

The city arms show an ox crossing a ford. The crest and supporters, which may have been granted when Elizabeth I visited the city in 1566, are a crowned demi-leopard holding a double rose, with an elephant and a beaver, from the arms of the city's high steward, Sir Francis Knollys, and Henry Norreys of Rycote, the captain of the city musters.

The motto is '*Fortis est veritas*', the 'Truth is Strong'. This image is taken from the coat of arms of 1866 on the wall of the Council Chamber in the Town Hall.

In memory of my grandparents, John and Elizabeth Thorpe

First published 2024

Amberley Publishing
The Hill, Stroud
Gloucestershire, GL5 4EP

www.amberley-books.com

Copyright © David Meara, 2024

The right of David Meara to be identified as the Author of this work has been asserted in accordance with the Copyrights, Designs and Patents Act 1988.

ISBN 978 1 3981 1680 1 (print)
ISBN 978 1 3981 1681 8 (ebook)

All rights reserved. No part of this book may be reprinted or reproduced or utilised in any form or by any electronic, mechanical or other means, now known or hereafter invented, including photocopying and recording, or in any information storage or retrieval system, without the permission in writing from the Publishers.

British Library Cataloguing in Publication Data.
A catalogue record for this book is available from the British Library.

Typesetting by Hurix Digital, India.
Printed in Great Britain.

Contents

Preface and Acknowledgements — 4
Introduction — 5

Chapter 1: The Beginnings — 8

Chapter 2: The Medieval Town — 16

Chapter 3: Early Modern Oxford — 33

Chapter 4: The Civil War — 41

Chapter 5: Oxford the Beautiful and Venerable City — 45

Chapter 6: Modern Oxford — 55

Chapter 7: The Twentieth Century — 74

Chapter 8: The Future — 93

Oxford Timeline — 95

Preface and Acknowledgements

This book has been a great pleasure to research and write because Oxford is the city where my grandparents made their home in 1920, where my parents met and married, where my twin brother and I were born in 1947 (in the Acland Nursing Home on the Banbury Road, demolished in 2004 to build a new graduate complex for Keble College), and where we both came to study at the University of Oxford in 1966. It is also the place where I met my wife Rosemary, and to which we have returned to live in retirement. Having experienced Oxford at different periods of my life it has been satisfying to discover more about its rich history, and to try to put together a historical account that weaves together the life of the city with the well-documented life of the university. Within the constraints of this book I can give no more than an overview of the past 1,500 years, and for greater detail I can only point the interested reader to the much fuller accounts in the *Victoria County History of Oxford*, Volume 4, the *Royal Commission on Historic Monuments, The City of Oxford*, and *The University of Oxford: A History*, by L. W. B. Brockliss. I have also found very useful *Oxford Outside The Guide Books* by Falconer Madan (Oxford, 1923), and *British Historic Towns Atlas*, Vol. VII (Oxford), edited by Alan Crossley, 2023.

I have tried to bring to life the bare bones of the historical narrative by adding at the end of each chapter pen-portraits of local personalities whose lives contributed to the history of the city. In many cases I have used rubbings of monumental brasses, as they are striking and unusual illustrations and reflect a life-long interest of my own. The illustrations are also a vital part of the story I am attempting to tell, and I am again deeply grateful to Stuart Vallis for his excellent photography.

I would also particularly like to thank John Chipperfield for his help in sourcing material from the *Oxford Mail* Photographic Archive, and for his extensive local knowledge which he has shared with me. I thank the *Oxford Mail* for permission to reproduce the images from their archive, and Robert Lind and the pilot Captain Barry Flower for aerial photography.

I am most grateful to Tracey Salt of TJS Typing Services for typing and retyping my manuscript with great patience, and for technical help in scanning images. I would like to thank my editor Marcus Pennington and all at Amberley Publishing for their help and support, and above all my wife Rosemary for her constant encouragement.

I dedicate this book to the memory of my grandparents, John and Elizabeth Thorpe, who first brought my family to Oxford and established the link with the City which has endured to this day.

Introduction

Matthew Arnold, the Victorian poet and writer, called Oxford 'Beautiful city! So venerable, so lovely, so serene and whispering from her towers the last enchantments of the Middle Ages...' The poet John Betjeman in the early twentieth century amplified that lyrical picture with more detail, identifying three Oxfords, Christminster, the market town portrayed by Thomas Hardy in his novel *Jude the Obscure*; Motopolis, the sprawling suburbs created by William Morris's, later Lord Nuffield's, motor works; and the University, which still holds magisterial sway in much of the city centre, and which has tended to hog much of the narrative of Oxford's story. Peter Snow, in his *Oxford Observed*, published at the end of the twentieth century, described yet more aspects of the city – medieval Oxford, county town Oxford, University Oxford, modern city centre Oxford, industrial Oxford, and suburban residential Oxford. And alongside those realities, Oxford as Alice-in-Wonderland Oxford, Inspector Morse land, C. S. Lewis territory, the tourist trails for the visitors and afficionados.

Aerial view of the city of Oxford, looking west, with Magdalen College bottom right, and the houses of north Oxford stretching away to the north. (Robert Lind)

So varied and multi-faceted is this city of dreaming spires that the travel writer Jan (formerly James) Morris in her book on *Oxford* (1965) simply summed Oxford up as 'this piebald prodigy ... a place that comes in flashes, sometimes lovely, sometimes dispiriting, and in just such a mood of changeable emotions, in which ecstasy and disillusion chase each other through the narrative...' She encourages us to view the story of the city.

Oxford is a city of many parts and many moods, a city that has witnessed the uneasy and sometimes violent tensions between town and gown, and over the centuries has gradually learnt to accommodate its divisions to the changing times and to absorb the contrasts, while responding to the pressures to grow and expand.

The roofs of the Covered Market. (Stuart Vallis)

On the eastern side of the tower of St Martin's, Carfax, is a fine clock with quarterboys, figures of men holding clubs, which strike the bell every fifteen minutes, replicas of those taken from the original church. (Stuart Vallis)

Chapter 1

The Beginnings

About 60 miles west of London, where the River Thames and the River Cherwell meet, there is a gravel spur of land broken by smaller water channels and surrounded by hills. There is evidence that in the Neolithic and early Bronze Age this area was the focus of a ceremonial monument complex. A henge monument has been identified near Keble Road, and also clusters of Bronze Age barrows on Port Meadow, at Binsey, South Hinksey and elsewhere. Small settlements at Rose Hill and Littlemore appear to have been abandoned in the late Iron Age, and the site became a backwater until there is evidence of further settlement in Roman times. At this period there was a pottery industry in the area between Cowley and Headington, and a crossing-point probably near Donnington Bridge, although no major Roman roads passed directly through Oxford.

It remained a place of scattered villas and of little importance until early in the eighth century AD, when the local Anglo-Saxon King Didarus lived here with his wife Safrida and daughter Frithswith, or Frideswide. Frideswide was courted by Algar, the pagan king of Mercia, who asked for her hand in marriage. When she refused him he threatened to abduct her, and so she fled to Oxford where she hid in the woods at Binsey. She established a chapel there, and a holy well, but King Algar came to Oxford, once again prepared to take her by force. As he approached the town he was struck blind by a bolt of lightning, but Frideswide took pity on him, prayed to St Margaret of Antioch, and used water from the well to restore his sight. Algar returned to his kingdom, and Frideswide founded an oratory on the site of the present twelfth-century church at Binsey. The holy well still exists in the churchyard of St Margaret's Binsey, the Treacle Well described by the Mad Hatter in Lewis Carroll's *Alice's Adventures in Wonderland*. The name derives from the medieval word 'triacle', which means any liquid with healing properties. There is also evidence that a small religious house for nuns was founded by Frideswide on the site of the present cathedral, *c.* AD 720–730, but this was burnt down in later Viking raids.

The name Oxford, or Oxnaforda, was first recorded in the tenth century, when Edward the Elder took control of the town. The city owes its name to its position as a crossing point of the Thames, a ford for the ox carts that carried people and goods. There has been much speculation about where this ford was, the likeliest crossing being the southern approach to the city via Folly Bridge. But scholars have also found evidence of a ford near the bridge on the western side leading to North Hinksey, and there was also an important route from London entering from the east across the River Cherwell near Magdalen Bridge.

There may well, therefore, have been several fords, but we do know that by the eleventh century a causeway with a series of stone bridges had been built on the southern route, known as Grandpont, by Robert D'Oilly, the Norman baron.

According to an Old English chronicle, by AD 911 Edward the Elder 'succeeded to London and Oxford and all the lands which owed obedience to them', by which time

This fourteenth-century stained glass from a window in the Latin Chapel in Christ Church Cathedral, Oxford, depicts St Frideswide, crowned, with a book and sceptre, and on the left St Margaret, with a dragon, cross and palm. Her cult flourished in the twelfth century, and continued until her shrine was destroyed at the Reformation.

St Margaret's Well, Binsey, associated with the story of St Frideswide, and the 'Treacle Well' of Lewis Carroll's *Alice's Adventures in Wonderland*. (Stuart Vallis)

Folly Bridge, a stone bridge over the River Thames, was built in 1825–27 to the designs of Ebenezer Perry, and replaced an earlier bridge which was part of a causeway known as Grandpont, originally built around 1085 by Robert D'Oilly, the Norman baron. This was one of the earliest crossing points of the River Thames, the site of a ford which gave Oxford its name. (Stuart Vallis)

Oxford had become a fortified site and an important regional centre. Edward (c. 874–924) was the eldest son of Alfred the Great, and succeeded him as King of Wessex in 899, developing a number of fortified towns and securing a series of victories against the Danes, thus ensuring that Wessex remained under Anglo-Saxon control. The original core of the town is the result of deliberate pre-conquest planning. A line of ramparts can be traced along Catte Street, Magpie Lane and Merton Street to St Ebbe's, and north to New Inn Hall Street, St Peter-le-Bailey and to St Michael at the North Gate, creating a small burh, or fortified settlement, of about 45 acres, with Carfax (*quatuor furcas*) in the centre of the crossroads.

	St Michael at the North Gate		
St Peter le Bailey	St Martin's Carfax	St Mary the Virgin	St Peter in the East
	St Michael at the South Gate St Aldate's		

St Martin's Tower is all that remains of the church, which was demolished in 1896. The tower dates from the twelfth century and is 74 feet tall. St Martin's used to be the civic church for the town, where the Mayor and Corporation came to worship, between 1122 and 1896, when the church was demolished and All Saints Church in the High Street became the Civic Church. (Stuart Vallis)

During the Anglo-Saxon period there were probably ten or eleven churches within the walled town, which by then had been extended east to include the area around St Peter-in-the-East, almost certainly in response to Viking attacks in the late tenth century. The Saxon tower of St Michael at the North Gate (1010–1060) is evidence of what the group of original churches may have looked like.

This is the period when Oxford established itself as a major commercial and administrative centre, a place of royal residence, and a strategic border town between the Kingdoms of Mercia and Wessex. It was the meeting place for several national councils, with a complex of buildings on the site of the castle, including St George's Tower, and St Frideswide's Minster as the mother church of the burh.

The Domesday Book of 1086 gives us a picture of a town of about 700–800 houses, a number owned by the great men of the realm, a population of about 1,000, and Portmaneit (Port Meadow) the great stretch of land (a site of 120 hectares) held in common by all the burgesses. The town was roughly square, the main streets running to the four gates, filled with shops, stalls and residential buildings. By 1066, the time of the Norman Conquest, Oxford had expanded both east and west beyond the original walls, and was one of the largest towns in England.

The development of the Saxon town, taken from a lecture by James Parker on the history of Oxford during the tenth and eleventh centuries, OUP, 1871. It shows the castle, with the town ramparts and the various parishes.

The west tower of the St Michael at the North Gate dates from the Saxon period, *c.* 1000. There are two tiers of twin bell openings with large balusters. (Stuart Vallis)

The original mound, or motte, of the castle dates from Saxon times, but the site was fortified in 1071 by Robert D'Oilly, who built the Church of St George, of which only the crypt remains. The motte is 250 feet in diameter at the base, 81 feet in diameter at the top, and 64 feet high. The bailey is surrounded by a rampart and a ditch. The Saxon tower of St George stood on the outer edge of the bailey.

The castle has witnessed many royal visits, including during the struggle in the twelfth century between King Stephen, grandson of William the Conqueror, and his cousin Matilda. Matilda, besieged in 1142 in the castle by Stephen, escaped from him one snowy December day by wrapping herself in a white cloak and fleeing to Wallingford. (Stuart Vallis)

Port Meadow is an ancient area of grazing land, still used for horses and cattle, originally given to the Freemen of Oxford by Alfred the Great. Their grazing rights are recorded in the Domesday Book of 1086. The meadow runs from Jericho to Wolvercote along the eastern bank of the River Thames.

St Frideswide, c. 650–727

Frithswith, or Frideswide, was an English princess from Wessex and an abbess who founded a monastery at Oxford, which later became the site of Christ Church College. The earliest account of the saint's life is the *Life of St Frideswide*, preserved in a twelfth-century manuscript. In art she is depicted holding the pastoral staff of an abbess, with a fountain springing up nearby and an ox at her feet. She was adopted as the patron saint of the city and university by the early fifteenth century, and her shrine remains a focal point of prayer in Christ Church Cathedral, where stands this modern statue of Frideswide by Peter Eugene Ball. (Stuart Vallis)

Chapter 2

The Medieval Town

After William had defeated King Harold at the Battle of Hastings, he proceeded to take steps to subdue the English lords by fortifying the country and installing trusted Norman lieutenants in the castles he built. The King's Constable Robert D'Oilly (*c.* 1071–1120) was put in charge of the strategic market town of Oxford, and he built a castle with motte and bailey near Castle Mill, which provided corn for the town. Inside the castle he built the collegiate church of St George, founded in 1074, possibly on the site of an earlier Saxon church and burial ground. The crypt still survives, and the Saxon tower, St George's Tower, originally guarded the western gate of the Saxon burh.

The rectangular St George's Tower, thought to predate the rest of the castle. It was possibly a watchtower associated with the original Saxon west gate of the town. It served as a prison for over 800 years. (Stuart Vallis)

The crypt of the former chapel of St George within the castle walls. Short piers with big capitals support a low ceiling. (Stuart Vallis)

Robert D'Oilly, who was remembered as a despoiler of churches until his conversion to Christianity, also built what is known as Grandpont, a raised 4-metre-wide causeway beneath the Abingdon Road, with a seventeen-arch stone bridge over the river, where Folly Bridge now stands. The earliest seal of 1191 already shows crenellated walls enclosing towered buildings, parts of which date from Norman times. Robert D'Oilly also founded an Augustinian priory at Osney, c. 1120, which grew in importance and became wealthy, with a range of impressive buildings, including a refectory, infirmary, chapter house, great hall, and schoolhouse.

Today in Mill Street, hidden in a cluster of narrow streets between the Great Western Railway lines and Osney Lock on the River Thames, you will find the remains of Osney Abbey, which in the 1540s was briefly the first cathedral of Oxford before the see was transferred to the church of St Frideswide, now Christ Church Cathedral. There isn't a lot to see, just a fifteenth-century archway, but an old print commissioned by John Aubrey, the seventeenth-century antiquary, gives an idea of how impressive the buildings originally were. Aubrey tells us in 1643: 'I got Mr Hesketh, Mr Dobson's man, a priest, to draw the ruins of Osney two or three ways before twas pulled down. Now the very foundation is digged up.' The drawing was engraved by Wenceslaus Hollar and published by the antiquary William Dugdale in his *Monasticon Anglicanum*. Now only that lopsided arch remains of one of the greatest buildings, which Oxford has lost. 'Great Tom', the bell that hangs in Tom Tower at Christ Church, was taken from the tower of Osney Abbey at the Dissolution of the Monasteries.

During the twelfth century the cult of St Frideswide grew in popularity and began to attract pilgrims.

In the year 1180 the supposed bones of Frideswide, which had been buried in the floor of her Saxon church, were discovered and put into a new shrine in the priory church. Her shrine became a place of pilgrimage, and many miracles of healing were recorded, some 100 of which were noted down by the prior, although no miracles were recorded after 1180.

An engraving of Osney Abbey as it appeared in 1640, commissioned by John Aubrey.

However, by now other groups of people, apart from pilgrims, were beginning to arrive in Oxford.

In the eleventh and twelfth centuries there would have been schools associated with St Frideswide's Priory and Osney Abbey, which probably encouraged individual teachers to visit, gather pupils and give lectures. The earliest systematised teaching is suggested in a letter of Theobaldus Stampensis, (Theobald of Étampes in France) *c*. AD 1095, in which he calls himself 'Magister Oxenefordiae'. The *Osney Chronicle*, written in the thirteenth century, records under the year 1133 that Master Robert Pullen began to lecture at Oxford on the Holy Scriptures. Here is the first evidence for the establishment of the future university. Soon individual teachers were giving courses in theology, law and philosophy.

Giraldus Cambrensis says in his *De Rebus a Se Gestis* that in AD 1187 he read out his Topographia Hiberniae at Oxford on three successive days, on the second of which he entertained the doctors of the various faculties.

Geoffrey of Monmouth, who resided in Oxford for twenty-three years during the early twelfth century, was a signature to a number of charters dated 1129–1151 connected with religious foundations near Oxford, and styled himself Magister, or Master. One of his co-signatories was Walter, Archdeacon of Oxford.

So, although in the twelfth and thirteenth centuries the town's prosperity was based on trade in wool and corn, the university was gradually establishing itself during this period. Although Oxford was still a small market town with about 4,000 inhabitants in AD 1200, it did have an archdeacon and an archdeacon's court, which ensured that clergy and ecclesiastical lawyers would regularly congregate there, fertile ground for academic

This engraving of *c.* 1770 shows the eleventh-century tower of St Michael's Church, the former north gate of the city, and the gabled medieval houses on the right, which still survive today. Above the archway of the gate was the Bocado, or gaol used for university prisoners. In the sixteenth century Thomas Cranmer and Archbishops Ridley and Latimer were detained here before being burnt at the stake.

study and disputation, and a focal point for students to gather. As a result of a riot in 1209 in which two students suspected of murder were hanged, many scholars abandoned Oxford, but after the town burgesses begged the Papal Legate to effect a reconciliation a Papal Bull of 20 June 1214 gave masters and students a collective, independent identity, and a chancellor was appointed to look after their rights. In these early and uncertain years a key figure was Robert Grosseteste (1175–1253), who from 1224 became the first Chancellor and later Bishop of Lincoln.

Grosseteste, who was a teacher at the Franciscan Friary of Greyfriars, once sited under the modern Westgate Shopping Centre, was a man of considerable learning, who wrote a number of scientific treatises which influenced the western scientific tradition. He advised a healthy balance between godly learning and good living. His presence at Oxford, together with scholars such as Roger Bacon, Duns Scotus and William of Ockham, was a mark of its growing intellectual reputation from the thirteenth century onwards. So began the growth of an institution within the city which had the potential to curb its civil liberties and take over many of its legal functions. The presence of so many young students, who could be both pugnacious and provocative, caused ongoing tensions and outbreaks of violence, which lasted on and off until the nineteenth century.

Recent research shows that fourteenth-century Oxford was a violent place to live. Researchers behind the University of Cambridge's Medieval Murder Map estimate the murder rate in late medieval Oxford to have been the equivalent of around 70 per 100,000. Professor Manuel Eisner, Directory of Cambridge University's Institute of Criminology,

has commented: 'As well as clashes between town and gown many students belonged to religious fraternities, which were an additional source of conflict within the student body.' He has plotted on a map where these bloody encounters occurred, showing that most attacks took place on the High Street and Cornmarket. One encounter involved David, a clerk from Northampton, who had been saying his prayers while he walked outside his home on Ship Street. Another man, John Lawrence, repeatedly barged into him, so David asked him to leave him in peace and returned to his lodging. John then banged on his front door, at which David emerged with a staff and beat him soundly. John died from his wounds fifteen days later, but not before both men had been locked up by the Chancellor of the University. Another incident concerned a prostitute, Margery de Hereford, who was murdered in 1299 by a scholar rather than paying what he owed. He was never brought to justice.

The most notorious riot between town and gown took place on St Scholastica's Day, 10 February 1355, when an argument in a tavern provoked arson and fighting for three days. Two thousand men poured in from the countryside crying 'Havoc, Havoc, give no quarter', and sixty scholars and twenty townsmen were killed, many injured and houses pillaged. As a result the mayor and bailiffs were imprisoned in the Tower of London, then condemned to attend a Mass at the Church of St Mary the Virgin each year and to give 60 pennies, representing the number of those who had died, which were then distributed to poor scholars. The city was put under a papal interdict for three years, and King Edward III issued a royal charter which made the town subject to the University. The penance continued until 1825, when instead the mayor and Corporation had to swear to uphold the ancient privileges of the University.

In spite of these troubles, the university had by the fourteenth century established itself as a major factor in the town's economy. By 1350 the university had well over 2,000 masters and students, was a corporation with its own coat of arms, chancellor and proctors, a Congregation House, built in 1320 against the north wall of the chancel of the church of St Mary the Virgin, and four faculties.

We can picture a town of timber-framed houses, remains of which can be seen at No. 126 High Street and Nos 109–10 High Street. The university students, all of whom were either priests or in minor orders, lived in halls or in monastic houses. Most halls eventually became colleges, established by wealthy churchmen close to the Crown. The earliest was Merton College founded in 1274, followed by University College in 1280, Balliol in 1282, Exeter in 1314, Oriel in 1324, and Queen's in 1341. As the colleges increased and expanded they bought up available land in the city so that scholars could live within the college precincts, thus lessening the friction between town and gown.

A scholar's life was rigorous. He had to study for seven years before becoming a Master of Arts. A typical day meant rising at 6.30 a.m. for breakfast; lectures began at 7.00 a.m. and lasted until 3.00 p.m. when there was time for recreation before supper in college at 6.00 p.m. Tackley's Inn, on the High Street and part of Oriel College, shows the kind of accommodation in which a medieval scholar lived. Behind shops on the High Street frontage was an academic hall, with two chambers and cellars below, shared by up to ten scholars, with a kitchen at the rear. The hall was used for lectures and meals, the chambers for sleeping and study.

Nestling under the north side of the Church of St Mary the Virgin is the Congregation House, where the members of the university met for examinations and sessions of the Chancellor's Court. It dates from the fourteenth century and consists of a stone vaulted lower room, with the first-floor room originally housing the University Library until the Bodleian's Duke Humphrey's Library was brought into use in 1480. The large windows in the Perpendicular style were made to match those in Adam de Brome's chapel. (Stuart Vallis)

Mob Quad, Merton College is the oldest quadrangle in Oxford, constructed between 1288 and 1378. The name Mob probably refers to the rowdy behaviour of the students who lived there. The upper floors of the south and west sides house the original library of 1373–78, one of the oldest libraries in Europe. The college was founded in 1264 by Walter de Merton, Chancellor of England and Bishop of Rochester. (Stuart Vallis)

This little Chapel, on a site just off the Crowley Road, is all that remains of the Hospital of St Bartholomew, founded by Henry I in the early twelfth century as a leper hospital, for twelve sick people and a chaplain. After years of mismanagement and neglect it was granted to Oriel College by Edward III.

St Bartholomew's Chapel dates from the fourteenth century and has a screen of 1651 given by Oriel College. The college still holds services in the chapel, using the Book of Common Prayer. (Stuart Vallis)

Tackley's Inn, Nos 106–7 High Street, was an academic hall acquired for Oriel College in 1324 and intended to house the first students. Built in *c.* 1320, it comprised a hall and chambers leased to scholars, with a stone vaulted cellar below. The south wall of the building, partly made of stone, contains a large two-light early fourteenth-century window. (Stuart Vallis)

Geoffrey Chaucer, writing at the end of the fourteenth century, gives us a description of one such student in the prologue to *The Miller's Tale*:

…At Oxenford … A Carpenter,
With him there was dwelling a poor scholar
Who had learned the arts, but all his desire
Was turned to learning astrology …

A room had he in that hostelry
Alone, without any company,
Very elegantly strewn with sweet-smelling herbs.

His Almagest, and books large and small,
His astrolabe, belonging to his art
His counting stones lie neatly apart,
Arranged on shelves at his bed's head:
His linen press covered with a red woolen cloth:

And all above there lay a fine psaltery,
On which at night he made melody
So sweetly that all the room rang:
And the *Angelus ad Virginem* he sang;
And after that he sang the King's Tune:
Very often his merry throat was blessed.
And thus this sweet clerk spent his time
Living on his friends' support and his own income.

Within the city merchants continued to deal in cloth, wine, brewing and corn, but increasingly these traditional manufacturing industries gave way to service trades dependent on the university. The occupations of the town bailiffs over the period 1300–1499 show the dominance of victualling, brewing, and distributive trades, such as apothecaries, mercers and chandlers. A number of watermills had been built, including Castle Mill, Trill Mill, Blackfriar's Mill and Osney Mill, which gradually altered the flow of the River Thames on the western and southern ends of the city. There was for a time a strong Jewish quarter in St Martin's and St Aldate's parishes, with a synagogue on the east side of St Aldate's, and a Jewish burial ground near the East Gate on the site of the Botanical Gardens. During the twelfth and thirteenth centuries there was a growing prejudice against Jewish communities, made up of Jews who had come over from France and had settled in England from 1066 onwards.

Before long, active persecution began, and this was formalised by the Synod of Oxford in 1222, convened at Osney Abbey, which reinforced the decrees of the Fourth Lateran Council of 1215, convened by Pope Innocent III, by introducing tithes on Jews, banning them from owning land, or building synagogues, prohibiting social interaction between Christians and Jews, and forcing them to wear a distinctive badge. This hostility

The library, originally founded on the collection of Humphrey, Duke of Gloucester, in 1447, was re-established by Thomas Bodley, Ambassador to the Netherlands under Queen Elizabeth I, in 1602, and the Schools Quadrangle dates from the early seventeenth century, built in the Jacobean Gothic style, with its splendid gate tower showing the five orders of classical architecture, with the statue of James I in the fourth storey. (Stuart Vallis)

culminated in the expulsion of all 3,000 Jews from England in 1290. They were not officially allowed to return until 1656. In 2022, on the 800th anniversary of the Synod of Oxford, Christian and Jewish leaders gathered in Christ Church Cathedral to mark the anniversary and express penitence for the persecution of the Jewish community then and over succeeding centuries.

During this period Oxford was dominated, architecturally, by its city walls, the castle, and its churches. It was a town of modest houses and narrow streets. The main thoroughfares were cobbled with a gutter running down the middle. Houses consisted of a cellar, a ground floor and a first floor, or 'solar'. Shops were small workspaces, often no bigger than 10 feet by 8 feet, set in front of domestic houses or academic halls. The life of the town centred on the merchant guilds, which regulated the trades and often maintained an altar or chantry chapel in one of the churches, and enjoyed certain privileges, including the right to serve the king at his feasts. The mayor was chosen from amongst the aldermen, and in addition two bailiffs were appointed, two chamberlains, who dealt with matters of finance, and four constables, as well as a town clerk. From the thirteenth century the town was represented in Parliament through the burgesses. The merchant guilds, craft guilds, religious fraternities and town council were all important parts of the framework of the social and religious life of the town, often dominated by a few wealthy families, including the Spicers, the Fettiplaces, and the Worminghalls.

This section of the old city wall dates from the twelfth century and was incorporated into New College in 1379 on the condition that the college should maintain it. The Lord Mayor and Corporation still inspect the wall every three years to ensure that obligation is fulfilled. The wall, with five bastions still intact, remains in remarkably good condition. (Stuart Vallis)

On the corner of Cornmarket and Ship Street is this fine late medieval timber-framed house, formerly the Ship Inn, with a six-light window on the upper floor. It was restored by Jesus College and now has shops on the ground floor. (Stuart Vallis)

A levy of 1380 for King Richard II indicates that the total population of Oxford, including colleges, halls and monastic institutions, had grown to about 5,000.

The range of trades included:

Bakers	17	Chandlers	10	Fishmongers	18
Barbers	10	Cobblers	9	Fullers	14
Bowyers	3	Cordwainers	12	Glovers	8
Brewers	30	Drapers	11	Goldsmiths	6
Butchers	16	Mercers		Grocers	7
Manciples	40	Slaters	12	Tanners	12
Masons	9	Stationers		Upholders	7
Millers	7	Booksellers	10	Latoners	
Skinners	24	Tailors	41	Weavers	28

Thus Oxford at the end of the fourteenth century was a self-contained town able to supply itself with all it needed, although there were frequent rivalries and disputes. Bakers and brewers, for instance, were widely distrusted and ordered to grind their flour only at the Castle Mill.

The brewers were located near the river, usually in the parish of St Thomas, while the butchers occupied Queen Street, the cordwainers controlled the tanneries in Cornmarket Street near the North Gate, and the drapers were located near Carfax. The glovers too were an important and influential guild, clustered near All Saints Church, where a special Mass was celebrated for them on Trinity Monday. Oxford gloves soon gained a reputation for fine quality, and a pair is still presented by the Lord Mayor to the Judge of the Assize when he holds court in Oxford. The goldsmiths occupied the part of the High Street from All Saints Church to where the frontage of the Covered Market now is, and cooks sold their wares between there and Carfax.

A cult of St Frideswide had developed from the twelfth century, and following the completion of the priory church her relics were transferred from the former shrine to the present shrine in 1289, and in 1398 the Bishop of Lincoln ordered that St Frideswide's Day should be observed on the 19 October. This shrine is located in the Latin Chapel in the cathedral, and would originally have had a large reliquary on top containing the bones of St Frideswide. The base is a low tomb chest with a canopy of three bays with shapely arches, moulded pillars, and splendid foliage ornament, all constructed between 1269 and 1289. However, because of the shortage of miracle cures, the shrine never became a major centre of pilgrimage, and within the town personal religious devotion was increasingly focused on the parishes with their guilds, fraternities, and chantry chapels commemorating particular families, such as Robert Worminghall in St Peter-le-Bailey and John of Ducklington in St Aldate's.

The town suffered considerably as a result of the Black Death in the fourteenth century (1348–1349), when Oxford probably lost a third of its population, and also during the Hundred Years' War. As a result of these disasters the town declined in economic and political importance in the later Middle Ages, which allowed the university to buy up land and expand. More colleges were founded, including New College (1379), Lincoln (1427), All Souls (1438), and Magdalen (1458), which followed the example of New College in arranging their main buildings around a quadrangle. Colleges were becoming richer and accordingly tried to outdo each other in magnificence to attract the best scholars. In 1427 the university began its first major building, The Divinity School, built by William Orchard with fine fan vaulting, and above it the library built to house the books given by Humphrey, Duke of Gloucester (1391–1447).

By the end of the fifteenth century Oxford had become a prosperous mercantile centre, with food, brewing and cloth trades predominating. The historic parishes remained strong and active centres of devotion, with fraternities of the Blessed Virgin Mary, altars tended by craft guilds, and chantry chapels commemorating the important families of the town. However, the ravages of plague and the decline of Thames navigation to London led to decay and stagnation, and spare land within the walls was soon snapped up by powerful individuals to expand existing colleges and build new ones. In addition new winds of change were beginning to influence the university and wider society, which would culminate in radical changes both for town and gown.

The Shrine of St Frideswide, in the North Choir Aisle, now the Latin Chapel, *c.* 1289, when the saints' remains were translated from the former shrine. It consists of a low tomb chest with a canopy with naturalistic foliage in the spandrels. (Stuart Vallis)

The Great Quad with the Gate Tower was the first part of the New College to be built, dating from the fourteenth century, and was the first college to be designed so that all the essential buildings – hall, chapel, library and sleeping accommodation – were placed in one quadrangle. This innovative design became the prototype for other colleges in Oxford and Cambridge. (Stuart Vallis)

The Divinity School is where the first written university examinations took place. Work began in 1427, but it took almost sixty years to complete. It has a fine vaulted ceiling given by Thomas Kemp, Bishop of London, and completed by a local mason, William Orchard. It has 455 carved bosses, many bearing the arms of benefactors. (Stuart Vallis)

Richard de Hakebourne MA (1322), Merton College Chapel

Richard was a Fellow of Merton College in 1296, and subsequently sub-warden several times. He was the owner of a book now in the college library, and donated two others. He may have known the founder of the college, Walter de Merton, Lord Chancellor of England and Bishop of Rochester, but he would certainly have seen the building of what is called Mob Quad, and the choir of the chapel, built in 1290–94. Walter de Merton wanted to extend education beyond those in the monastic orders, whom he felt were too conservative, and Richard de Hakebourne was a member of the secular clergy, who was also rector of Wolford, a college living in Warwickshire. We can picture him in his college chamber, sitting at his desk, with books to hand, a candlestick to illumine his studies, and his black gown hanging on a peg. His brass, set in a slab of Purbeck marble and showing him in half-effigy wearing mass vestments, is the earliest recorded monument in the chapel. (Author's collection)

Henry Sever (1471), Merton College, Oxford

Henry Sever became a Fellow of Merton College in 1419. He was the chaplain and almoner to King Henry VI, he was made the first Provost of Eton in 1440, and he became Chancellor of the University in 1442. He became Chancellor of St Paul's Cathedral in 1449, and from 1456 until his death was the Warden of Merton College. In the reign of Edward IV he is said to have held fourteen ecclesiastical preferments, a testimony to his administrative ability and ambition. On his death he made many bequests to Merton College, including seventeen books from his library, and property in Fleet Street, London and Tilbury in Essex. While warden he rebuilt the warden's lodgings, and the Holywell Tower, which won him the accolade of the second founder of the college. He is an example of how an ambitious and talented man could rise both within the university and the wider church. His fine monument, a large memorial brass in the choir, shows him standing under a triple canopy, wearing a cassock, surplice, cope and amice. The cope, which is fastened by a morse, is elaborately decorated with figures of saints, including St James the Great, St James the Less, St Paul, St John the Baptist, St John the Evangelist, St Bartholomew and St Thomas. (Author's collection)

Chapter 3

Early Modern Oxford

The sixteenth century was dominated by the religious upheavals which we know as the Reformation, murderous disputes about the authority of the Church, the power of the Papacy, and the role of scripture. After King Henry VIII's break with Rome and the establishment of the Church of England with Henry as its head, the physical effects were dramatic. The monasteries were dissolved and their contents plundered. In Oxford monastic houses were closed, as well as the exclusively monastic halls, Gloucester, Durham, Canterbury, St Bernard's and St Mary's. Finally the great abbeys of Rewley, Godstow and Osney were dissolved and their shrines dismantled.

In 1546 Henry confiscated Osney's lands and assets in order to re-endow the college which Cardinal Wolsey had founded in 1524 on the site of St Frideswide's Priory. Following Wolsey's fall from grace it was refounded by Henry as Christ Church College. Robert King, who had become the Abbot of Osney in 1537, was consecrated the first bishop of Oxford, and is buried in the cathedral under a tomb with a vaulted canopy at the entrance to the Chapel of Remembrance. The new diocese, carved out of the vast diocese of Lincoln, covered the county of Oxfordshire, and in 1542 the former abbey church at Osney became the cathedral: But four years later the cathedral was moved to the former Frideswide's Priory, and thus Christ Church Cathedral holds the unique distinction of being both the cathedral of the Diocese of Oxford and the college chapel.

We have to remind ourselves that before the Dissolution Oxford was surrounded by a network of eleven religious houses, from Blackfriars outside the South Gate to Austin Friars where Wadham College now is. The recent discovery of the remains of St Mary's College in New Inn, Hall Street founded by Augustinian Canons in 1435, has highlighted how much Oxford lost during the Reformation years. Professor Gerard Kilroy takes up the story:

> The antiquary, Anthony à Wood (1632–1695), records that the college was hardly damaged in 1541, and that it became the subject of a fierce dispute in 1556, during the reign of Mary Tudor, between John Wayte, then the Mayor of Oxford, and Dr William Tresham, the vice-chancellor for that year.
>
> Tresham made an expensive journey to London lasting 32 days, during which, on behalf of the university, he invited Cardinal Pole to be chancellor, and established the title of St Mary's College as belonging to John Fettiplace. The cardinal supported Tresham's plea for St Mary's, and Wayte was 'commanded to make no further spoile there'; Wayte had clearly been selling off the lead, timber, glass and stone as he continued to do in the 1560s.

Unfortunately, when Queen Mary and Cardinal Pole died, John Wayte reasserted his claim, and the buildings were turned into a house of correction for poor children.

Eventually the property was conveyed to Brasenose College, who pulled it down and reused the materials, including incorporating the splendid hammerbeam roof in their new chapel. The roof can still be seen today, a reminder of the terrible destruction at the time of the Dissolution, and the impact this had on both the religious life of the city and the academic life of the university. Professor Kilroy highlights the international nature of these monastic institutions, with scholars from all over Europe residing in them, and the subsequent shortage of theologians, commented on in June 1560 by the reformer John Jewell (1522–1571), who complained to Pietro Martire Vermigli, his 'father and most esteemed master in Christ', that 'everything (in Oxford) is falling into ruin and decay: for the colleges are now filled with mere boys, and empty of learning.'

During the Early Modern period, from the mid-sixteenth century to the outbreak of the Civil War, Oxford once again grew in prosperity, its population doubling to about 10,000. More colleges were established, including Brasenose (1509), Corpus Christi (1517) and Cardinal College (later Christ Church) in 1525. In spite of sporadic outbreaks of plague, the upheavals of the Reformation and the years of the Marian persecution, when archbishops Ridley and Latimer were imprisoned and burnt at the stake in Broad Street, the spot marked today by a cross in the roadway, new college buildings were erected to meet the surge in demand for university education, so beginning the transformation of the city into a place of great beauty. By 1552 three quarters of the student body were living within their own college walls, which tended to lessen the friction between town and gown. As the medieval pattern of town life focused on the church calendar and religious houses gave way to the emergence of an urban community held together by the craft guilds, the city council and the framework of civic life, so within the university the emphasis on speculative philosophy and theology declined, in the face of the influence of Renaissance humanism, Scriptural analysis, and the writing of Classical Latin and Greek, aimed at educating effective and learned Christian ministers.

At the east end of St Martin's Church at Carfax a sheltered recess, known as 'Penniless Bench', was erected in 1546, where justice was administered by the mayor and bailiffs. Many distinguished visitors to Oxford halted here and were received by the City Fathers and the University authorities, including Quen Elizabeth I, who took particular interest in the university, being entertained for seven days in 1566. It was also a gathering place for those attending the mayor and Corporation when they went in procession to hear the sermon at the City Church.

Queen Elizabeth I's close involvement with the affairs of the university meant that in 1581 the university passed a statute that required all coming into residence to swear that the queen was head of the reformed church, and to agree that the 39 Articles of 1571 were a true statement of faith. 'Thereafter', writes Laurence Brockliss in *A Brief History of the University of Oxford* (2019), 'until 1854, Oxford was a confessional university. Only Anglicans, or those willing to subscribe to Anglicanism, could attend.'

Thereafter the Crown continued to involve itself in the university to ensure its adherence to the Protestant religion. The masters' powers were eroded, and although they retained the right to elect the chancellor, from 1634 the business of the university was transacted by the Hebdomadal Board, which consisted of the vice-chancellor, the proctors, and the heads of houses.

Down a narrow passage off the south side of the High Street is Kemp Hall, a many-gabled timber-framed town house built for Alderman William Boswell in 1637. The doorway has a little canopy and oriel windows jut outwards on brackets on the upper floor. (Stuart Vallis)

We can glimpse something of the prosperity of the town from the fine Kemp Hall in Carter's Passage off the High Street. In the reign of Henry VIII there was a house here built for Alderman Richard Kent, but the present house dates from 1637, the date inscribed over the doorway. It was called Kemp Hall because it was thought that John Kemp, Archbishop of Canterbury, studied there. In the early twentieth century it was used as the police station, but it is now a restaurant. Oxford's flourishing intellectual and social life is symbolised by the Coffee House at the corner of High Street and Queen's Lane, recorded in 1654, and No. 90 High Street, also a coffee house, which became a meeting place for intellectuals, artists and thinkers, including Sir Christopher Wren. The engaging seventeenth-century antiquarian and chronicler Anthony à Wood, born in Oxford in 1632, was a regular visitor to the coffee houses and complained that students spent too much time in them in frivolous talk. Another fine house of this period, *c.* 1620, survives as the Old Palace, Nos 96–97 St Aldate's, and now home to the Catholic Chaplaincy; and No. 3 Cornmarket Street conceals behind its eighteenth-century façade a timber-framed sixteenth-century building, originally an inn, The Crown Tavern, with fine painted walls concealed behind seventeenth-century oak panelling. The owner John Davenant was a friend of the playwright William Shakespeare, who stayed here when travelling from London into Warwickshire.

A coffee house on this site was originally established by Cirques Jobson, a Levantine Jew from Syria, in the early seventeenth century. Oxford was the first place in England to open a coffee house, and the present building dates back to 1654. (Stuart Vallis)

The Old Palace, now the Catholic Chaplaincy, situated on Rose Place, was built in 1622–28, with gables and oriel windows. It was built by Alderman Thomas Smith (d. 1646) reputedly at a cost of £1,300, and later lived in by Unton Croke MP. It was one of the largest domestic properties at the time in Oxford.

It was at the font of St Martin's Church, Carfax, that John Davenant's second son William was baptised, on 3 March 1606, witnessed by the baby's godfather, William Shakespeare. The boy went on to become Poet Laureate in 1638. The Bodleian Library holds a Shakespeare First Folio, the first edition of the collected plays of Shakespeare, collated and published in 1623, seven years after his death. Its preliminary pages include poems by various contemporary poets extolling his memory. Recent research suggests that its makers portrayed Shakespeare as a member of a clique of poets and writers, all of whom were associated with Oxford University. His funerary monument in Holy Trinity Church, Stratford-upon-Avon, is remarkably similar in style to those of Oxford academics. Shakespeare commissioned the monument in his own lifetime from Nicholas Johnson, his figure wearing an Oxford University undergraduate gown, and with details echoing other monuments in Oxford college chapels, suggesting that he wanted to be memorialised with links to the university, which as far as we know he never attended. This research suggests that associating with the university and this group of Oxford poets helped to create and enhance his 'brand' and swell his reputation.

The Mitre Inn stands on a site which has been occupied by an inn from the thirteenth century. Underneath is a vaulted thirteenth-century cellar, and the present frontage dates from 1680, extended in the eighteenth century with attractive bay windows. In its heyday it was a busy coaching inn and a popular meeting place for town and gown alike. It remains a restaurant today. (Stuart Vallis)

There were by now a number of taverns in the city, serving both the resident population and those visiting Oxford, including The Crown Tavern, the Golden Cross, also in Cornmarket, and perhaps best known of all, The Mitre in the High Street. This inn, on a site over 700 years old, has played host to generations of Oxford people, and has been frequently mentioned in books about Oxford, because of its hospitality and venerable atmosphere, with its seventeenth-century panelling and vaulted cellars dating from the Norman period. Anthony à Wood states: 'This place in King Henry III's reign belonged to Philip Pady a burgesse of Oxon,' and it remained in the hands of the same owners for 400 years. Wood also says that the first stagecoaches ran to Oxford in 1661, and that in 1669 one 'flying coach' made the journey from Oxford to London in one day. This increasing accessibility made Oxford an ideal strategic base when civil war broke out in 1642.

The Kings Arms inn dates from the early seventeenth century. It is an attractive building on the corner of Holywell and Parks Road, with a five-bay stuccoed frontage. (Stuart Vallis)

Elizabeth Franklin (1622), St Cross, Holywell, Oxford

We know almost nothing about Elizabeth Franklin, except that she was the wife of Thomas Franklin, who, according to the historian Anthony à Wood, was 'keeper of the inne called the Kinges Armes in Holywell', and that she was a woman of piety. As an innkeeper's wife in the early seventeenth century she would doubtless have helped her husband in the running of the hostelry, serving food and drink and keeping good order. The King's Arms still exists in Oxford today, on the corner of Holywell and Parks Road. The site was originally occupied by the Augustinian Friars, but after the Dissolution of the Monasteries the land passed to the city, and in 1607 the council gave Thomas Franklin a licence to set up an inn. The king referred to in the inn's name was King James I, who was involved with the founding of Wadham College. The inn opened its doors on 18 September 1607. It became a popular location for putting on plays and later a busy coaching inn. Elizabeth must have been a woman of piety and repute, because on her death a brass memorial was erected in St Cross Church, showing her lying in a two-poster bed, with curtains draped around the posts, wearing a cap, and praying 'Thy will be done' towards a sunburst in the upper left corner, where three angels say, 'Receive they crowne', 'Thy prayer is heard', and 'Thy patience is trid'. On the coverlet of the bed lie three babies in shrouds and one in swaddling clothes with the words 'Of such are the Kingdom of Heaven.'

Chapter 4

The Civil War

Oxford did not escape being caught up in the national convulsion we know as the Civil War, fought between the Roundheads and the Cavaliers from 1642 to 1646.

The conflict erupted because King Charles I maintained the divine right of kings to rule unhindered over their subjects at a time when many people felt that he should only rule by the will of Parliament. Charles' unwillingness to compromise meant that civil war was inevitable, and Oxford became the Royalist capital and chief residence of the king, the court, and the Royalist army. So between October 1642 and its surrender to the Parliamentary forces in 1646, Oxford became, effectively, the capital city of England.

However, it was a city of divided loyalties, because while the university tended to support the king, many of the townspeople were sympathetic to the Parliamentarians, so when a regiment of soldiers left the city to join the king on 10 September 1642, Parliamentary forces were able to occupy the city from 12 September until just before the Battle of Edgehill on 23 October, when King Charles I and his army, after their humiliating defeat, decided to regroup at Oxford. The king moved into the dean's lodgings at Christ Church. Corpus Christi, Merton and Oriel colleges were occupied by other members of the court, and when she arrived from Holland in May 1643, Queen Henrietta Maria was given lodgings in the fifteenth-century Fitzjames Gateway, in Merton College. Other officials and soldiers were given billets in the city, and householders were paid an allowance of 3s 6d a week for feeding them, but accommodation was often primitive. In 1643 Ann, Lady Fanshawe, complained that 'from as good house as any gentleman of England we had come to a baker's house in an obscure street, and from rooms well furnished to lie in a very bad bed in a garret.'

The city became a military camp, with artillery stored in New College Cloisters and Tower, clothing in the Music and Astronomy Schools, and a mint established in New Inn Hall in January 1643. Although a scheme of fortifications was carried out, the town was still vulnerable to the Parliamentary army, and so the rivers Cherwell and Isis were dammed, and the water meadows flooded.

There was a determined effort to continue the life of the court, and the Crown and Crown Jewels were smuggled out of London so that the king could appear in his full magnificence. The Exchequer and Courts of Law were all relocated from Westminster to Oxford, and in January 1644 the king summoned Parliament to assemble at Oxford, where 175 MPs attended him in the hall at Christ Church, later occupying the Convocation House.

However, by now the tide was beginning to turn against the Royalists. In June 1644 Parliamentary forces under Sir William Waller and the Earl of Essex had nearly surrounded the city, in July the City of York surrendered and the king's power in the north was broken, in May 1645 Oxford was under siege, and by March 1646 the Royalist

FIG. 26. DE GOMME'S PLAN OF THE DEFENCES OF OXFORD, 1644, traced on a modern map of the city.
Reproduced by courtesy of the Alden Press (Oxford), Ltd.

Civil War map of Oxford. Sir Bernard de Gomme's plan of the defences around Oxford during the Civil War, 1644. The River Isis became the defensive barrier on the southern side of the City. De Gomme was a Dutch military engineer born in 1620, who served with the Royalist army as an engineer and quartermaster from 1642 to 1646.

army was in retreat and many parts of the country were falling to the Parliamentarians. On 27 April 1646, the king rode out of Oxford in disguise, eventually being captured on 5 May. From 3 May to 20 May Oxford was again under siege and on 25 June 1646, the city surrendered and the keys were handed to General Fairfax. The Royal Princes Rupert and Maurice and a garrison of 3,000 men were allowed to march out of the city and disperse 15 miles from Oxford.

From 1642 to 1646 Oxford had been the Royalist capital of England, had been twice besieged, and because of the overcrowded conditions had suffered an outbreak of typhus during the summer of 1643. Politically the town's allegiance was divided; at the beginning of the war most townsmen were more sympathetic to the Parliamentarians but on the whole feelings remained moderate, even though there was considerable reluctance to pay

Cartographer David Loggan (1635–1700) engraved his map of Oxford after the Civil War of 1642–46. It is the first accurate map of Oxford, with north at the bottom.

the large sums of money required by the king or to work on the fortifications. Surprisingly material damage done to the city during the occupation and sieges was not extensive, and David Loggan's map of the city of 1675 shows a town with many fine buildings of distinction, reflecting 'a vigorous, confident and better-educated urban community, able to compete on equal terms with the university, proud to belong to 'so eminent a city', and keen to display individual status and wealth in fine houses' (Alan Crossley).

The elaborate defensive earthworks which had been thrown up around the city were dismantled, and the castle was reduced to little more than a mound next to St George's Tower. A short section of the defences is still visible beside Rhodes House on South Parks Road.

The city council hoped to regain some of its lost powers, because the university had lost favour due to its Royalist sympathies, but the university cunningly managed to acquire Oliver Cromwell as its Chancellor, and soon reasserted its rights on the accession of King Charles II in 1660.

William, Viscount Brouncker (d. 1645)

Sir William, 1st Viscount Brouncker of Lyons in the Province of Leinster, Ireland, 1585-1645, was the son of Sir Henry Brouncker and Ann Parker. He went up to Oxford University, attending St Edmund Hall, and was subsequently invested as a knight in 1615, holding the office of Gentleman of the Privy Chamber to King Charles I. He married Winifred Leigh and they had two sons. He was on the king's side when the Civil War broke out and remained in Oxford during the hostilities.

Samuel Pepys records that Brouncker bought his peerage for £1,200, and 'swore the same day that he had not 12 pence left to pay for his dinner'. He didn't enjoy his new status for long because he died two months later and was buried on 20 November in Christ Church Cathedral. The monument shows him sitting opposite his wife at either end of the bed, looking away from each other, with a skull between them. (Stuart Vallis)

Chapter 5

Oxford the Beautiful and Venerable City

Although many medieval and monastic buildings had been demolished to make way for fine university buildings, the basic street plan of the city had been retained. However, although Carfax and High Street were swept regularly, other streets and lanes were 'stinking cartways', littered with offal, dung heaps and other rubbish. The university also complained about the obstruction of streets by signs, chimneys and overhanging buildings. The Carfax Conduit, completed in 1617, a handsome structure, but built in the middle of the busy crossroads at the centre of the city, was soon regarded as a serious obstruction. It wasn't finally removed until the eighteenth century.

However, the seventeenth century saw one of the greatest periods of new building, including the Sheldonian Theatre (1664–1669), the Old Ashmolean Museum (1678–1683), the Physic Garden (1621–1633), Wadham College, (1610–1613) and new quadrangles at University, Merton, Exeter, Oriel, Lincoln, Brasenose, Trinity, St John's and Pembroke colleges, and Tom Tower at Christ Church. A number of these buildings were designed by Sir Christopher Wren, including Trinity College Chapel and the Sheldonian Theatre in Broad Street.

Some green spaces were maintained in the city because of the increasing demand by undergraduates for places of recreation, including tennis courts and bowling greens. In 1621 Henry Danvers, Earl of Danby, enclosed an open space at the eastern end of the High Street, opposite Magdalen College, and created a physic garden for growing herbs and plants for use in medicine and science. It was laid out on the site of the city's Jewish cemetery, and much of the original design has survived. A series of rectangular beds covering about 5 acres are surrounded by 14-feet-high walls, and the fourth side facing the High Street is enclosed by laboratory buildings and a triumphal arch designed in the baroque style by Nicholas Stone in 1632.

The great courtyard inns, the Mitre, the Golden Cross, and the Star (later the Clarendon Hotel), were expanded during the seventeenth century, and the Tabard Inn, later called the Angel, on the High Street was enlarged with extensive stabling and a 110-foot frontage. Most of the housing in the town was timber-framed, as is evident from surviving groups of old houses in Holywell, Ship Street and Pembroke Street. The wealthiest and most prosperous parts of the city were in the parishes of All Saints, St Martin's, St Mary the Virgin and St Aldates, the eastern end of the High Street being an increasingly fashionable place to live.

When the monarchy was restored in 1660 there was a flurry of new building. The Clarendon Building was designed by Nicholas Hawksmoor, who also drew up a bold

This highly ornate Jacobean conduit was originally presented to the city in 1610 by a student of Christ Church, Otho Nicholson, for the distribution of water brought in pipes from the Hinksey springs. It was removed from Carfax in 1787 to relieve the traffic congestion and set up by the 2nd Earl Harcourt in his park at Nuneham Courtney as an eye-catching feature. Nicholson's initials appear prominently, repeated around the balustrade. (Author's collection)

The Old Ashmolean Museum is the original building in which the art and antiquities collection begun by Elias Ashmole in 1683 was housed. It was probably designed by Thomas Wood and completed in 1683. It is one of the most distinguished seventeenth-century buildings in Oxford. (Stuart Vallis)

The magnificent Tom Tower, the main entrance to Christ Church, was designed by Christopher Wren in 1681. The lower half was originally part of Cardinal Wolsey's College and built in the late Perpendicular Gothic style, the upper part Wren's version of Gothic. The tower houses the Great Tom bell, which chimes 101 times each evening at 9.05 p.m., one for each member of the original foundation. The bell was named after Thomas Becket, the Archbishop of Canterbury murdered in 1170 on the orders of Henry II. (Stuart Vallis)

Commissioned as an assembly hall for university ceremonies by Gilbert Sheldon, Chancellor of the University, in 1662, the Sheldonian Theatre was designed by Christopher Wren, his first major architectural scheme, and completed 1663–1669. It was modelled on the open-air Theatre of Marcellus in Rome. The seven-bay façade with arched main windows faces towards the Divinity School. Inside there is a 70-foot-diameter flat ceiling painted with a depiction of The Triumph of Religion, Arts and Science. (Stuart Vallis)

One of the most delightful streets in the city, Holywell Street is lined with a charming collection of seventeenth- and eighteenth-century houses, some timber-framed with overhanging gables, some with stuccoed fronts and Georgian façades. (Stuart Vallis)

scheme to replan much of the central area, opening up new vistas, which included demolishing St Mary the Virgin, but thankfully this came to nothing. The Sheldonian Theatre was begun in 1663 as the focal point of the university, designed by Christopher Wren, the Savilian Professor of Astronomy at the university, and one of a group of brilliant scholars, including Robert Boyle, who went on to form the Royal Society, and who met to discuss together in one of the fashionable coffee houses in the High Street. The present Queen's Lane Café claims to be the oldest continuously operating coffee house in Oxford, and could well have been one of the places where they met.

In spite of this activity the university went into a decline after the Civil War, and the city's economy slowed down too. The overall population fell, and economic life came to depend even more on a closed community of shopkeepers and retailers, with a strong hereditary element, catering for a smaller but lavish academic community. Many younger undergraduates merely resided at the university for a couple of years, treating it as a finishing school before seeking preferment in the church or a career in politics.

This aerial view shows the university buildings clustered around Radcliffe Square, with the Radcliffe Camera in the centre (1749), St Mary the Virgin at the bottom, All Souls College on the right, the Bodleian Library and Divinity School at the top, and Brasenose College on the left. The eighteenth-century Clarendon Building is at the very top, and the nineteenth-century chapel of Exeter College at the far top left. This glorious assemblage of buildings from the fourteenth to the nineteenth centuries drew many visitors to Oxford from the eighteenth century onwards. (Robert Lind)

This state of affairs only exacerbated the ancient rivalry between town and gown, with the political and religious divides during the reign of Charles II adding to the hostility. Beneath most disputes lay the issue of who governed the city, with the added poison of what we would now call class prejudice. The mayor expected to have precedence over the vice-chancellor, but usually, especially during royal visits, the university played the major role. In 1702 there was a tussle over precedence in the procession when Queen Anne visited the city and dignitaries were injured in the fighting. The university drew a contrast between the two corporations, the one 'engaged in the profession of the most noble and useful sciences: the other consisting partly of creditable retail tradesmen, but for the most part of the lower rank of mechanics.' (Quoted by Alan Crossley in *City and University*, in Seventeenth Century Oxford. Ed Nicholas Tyacke OUP.)

Within these struggles for power between city and university the university usually held the upper hand because it enjoyed the monarch's favour, and had the power of excommunication, or 'discommoning', which denied the victim all contact with the scholars. There were constant disputes between town and gown in the sixteenth and seventeenth centuries, and the university's claim to priority was clearly stated in 1640: 'Where two corporations live together there is a necessity that one of them be subject to the other.' The university's charter of 1636 confirmed the university's right to police the streets and seek out 'suspicious persons' by day and by night, but resentment of the university proctors and the night curfew continued to simmer. In spite of this the city enjoyed a thriving civic life. A royal charter of 1605 confirmed Oxford as a free city with a Corporation, mayor, bailiffs and commonalty with all their ancient rights. The full council met in formal session, wearing their gowns, and after the suppression of the City Guilds the role of the council in the social and ceremonial life of the city became increasingly important. The year began at Michaelmas, 29 September, with the Mayoral Election Dinner for all freemen. The mayor's power and prestige were considerable as he was also the chief magistrate. The two bailiffs also exercised considerable influence as they were responsible for peacekeeping, the courts, and the prison.

During the eighteenth century we can picture a smaller university enjoying a privileged life serviced by a thriving community of shopkeepers and other retailers in a tight network of closed family relationships, the two bodies frequently at loggerheads, especially as the mayor and council had grown in importance within the life of the city. The period witnessed a further building boom, with the design of Peckwater Quad at Christ Church, a classical Front Quad, North Quad Chapel and Hall by Nicholas Hawksmoor at Queen's College, the Great Quad and Codrington Library at All Souls, also designed by Hawksmoor, and the Radcliffe Camera based on an idea of Hawksmoor's, but actually designed by James Gibbs and completed in 1749. The Radcliffe Infirmary, designed by Stiff Leadbetter was opened in 1770, and the Radcliffe Observatory, designed by James Wyatt, was completed in 1794. All these buildings reflect the munificence of one man, the famous Oxford physician Dr John Radcliffe (1650–1714), who bequeathed money in his will to found a library and whose charitable trust founded in 1714 still operates today. The Infirmary built on a 5-acre site in the fields of St Giles', donated by Thomas Rowney (the MP for Oxford between 1722 and 1759), provided hospital care for poor inhabitants and was staffed by six physicians and four surgeons.

St Giles' House, a fine seven-bay stone house, was built in 1702 for Thomas Rowney, Oxford's MP. Inside are fine staircases and plaster ceilings. From 1852 it served as the Judge's Lodging and is now part of St John's College. (Stuart Vallis)

Peckwater Quadrangle, Christ Church, in the neoclassical style, was built between 1705 and 1714 on the site of a medieval inn. The building was designed by Henry Aldrich, Dean of Christ Church. It occupies three sides of the quadrangle, each side having fifteen bays in perfect proportion. (Stuart Vallis)

The Radcliffe Observatory was designed by James Wyatt and completed in 1794, described by Pevsner as 'architecturally the finest observatory in Europe'. The top half of the building, octagonal in shape, is a version of The Tower of the Winds in Athens. In front is a modern statue of the Oxford physician and benefactor Dr John Radcliffe. (Stuart Vallis)

The city's streetscape was embellished with an ensemble of fine university and college buildings unsurpassed by any other European university, and became a tourist destination with a lively cultural scene, including concerts in the Holywell Music Room, numerous coffee houses, and a thriving intellectual life, especially once the University Press had been established by Dr John Fell (1625–1686), the Dean of Christ Church, which gave the university a platform to publish research, and thus raise its profile. During this period church life stagnated, most parish churches being served by college fellows, with incomes mainly dependent on the annual Easter offerings. Furthermore, by the later years of the eighteenth century the influence of the City Council had declined because it had degenerated into an out-of-touch clique, burdened with debt and corruption, and no longer representative of the wider community. The time was right for some radical reform.

The impending visit of the celebrated musician Handel in 1733 stimulated the building of a proper concert room, built in 1742–48, and designed by Thomas Camplin. It has a white pedimented three-bay front and a later porch. (Stuart Vallis)

Nicholas and Dorothy Wadham (1534–1618), Founders of Wadham College, Oxford

Dorothy was the eldest child of Sir William Petre (1505–1572), Secretary of State to four successive Tudor monarchs, and a wealthy man because of the property he owned. She grew up in the family home, Ingatestone Hall in Essex, and in 1555 married Nicholas Wadham (1531–1609). They lived at Ilton, Somerset, and on his death Dorothy accomplished Nicholas' wish to found a college in Oxford. A site was acquired in 1610, with William Arnold as the architect, and its statutes were approved by Dorothy in 1612. She was involved in every aspect of the setting up of the college, but never actually visited the site, dying on 16 May 1618 at Branscombe in Devon. She is buried beside her husband in the Wadham Chapel in St Mary's Church, Ilminster, Somerset, and commemorated by a fine memorial brass, showing Nicholas as a knight in armour, and her wearing a close-fitting bodice with an ample pleated skirt, and a Mary Queen of Scots headdress. They are described as the Founder and Foundress of Wadham College, and below his effigy is a shield of arms showing Wadham impaled with Petre, which were adopted as the arms of Wadham College. (Author's collection)

Chapter 6

Modern Oxford

The historian H. E. Salter has remarked: 'As regards the geography of Oxford the year 1771 is the end of the Middle Ages.' He is referring to the establishment of the Paving Commission of 1771, which marks the beginning of Oxford's modern history. By this stage the city supported a total population of about 10,000, of which about 3,000 belonged to the university, but the central area was crowded, the streets full of stallholders, the roadway covered in filth and littered with debris, and the surface uneven and treacherous. The Paving Commission was the first attempt at modern town planning. The street markets were brought to an end, and the Covered Market was built in 1774 as a home for them, designed by John Gwynne, who also designed Magdalen Bridge in 1778. Gwynne (1713–1786) was an architect and civil engineer, and a friend of Dr Samuel Johnson. The market building at first chiefly housed butchers' shops, but other stalls soon proliferated, with fish mongers, fruit and vegetable stalls, cheesemongers, and florists, all serving the needs of the colleges. The Covered Market is still a lively centre of trade today, but now cafés, gift shops and boutiques predominate. By an Act of 1771 the university appointed clerks to the market and fixed the market days. Their duties gradually declined until by 1975 their only duty was to declare twice a year to college bursars the price of wheat and barley on which college rents were based.

Porches, protruding shop signs and other projections were ordered to be removed, the paving of the High Street was completed in 1779, and the Carfax Conduit was finally removed in 1787. The Oxford Canal Company was incorporated in 1769, and the canal finally reached Oxford in 1790, entering the city along the eastern edge of Port Meadow, and terminating at the New Road Wharves. The company built a stone-fronted office building in New Inn Hall Street in 1797, which is now part of St Peter's College. While the opening of the canal brought increased traffic and provided opportunities for employment, the city remained relatively untouched by the Industrial Revolution.

In 1825 William Carter moved his iron foundry from Summertown to the banks of the Oxford Canal, specialising in iron castings, ornamental ironwork and agricultural machinery, and where the firm continued until 2005. The red-brick gateway to the works can still be seen on Walton Well Road in Jericho.

A gasworks was established in St Ebbe's near Grandpont, opening in May 1818 under the name of 'The Oxford Gas, Light and Coke Company', and far enough away from the central area so that the noise and fumes did not affect the residents too much. Soon, hundreds of terraced houses were built around the site, and nearer to Folly Bridge there were further wharves, timber yards, and the city waterworks, thus creating what could be described as the city's industrial area.

Oxford remained a bustling commercial centre at the junction of major routes both east to west and north to south. Its position made it important for the marketing of corn,

The Covered Market was established in 1774 as a home for the many stallholders who had filled the streets of central Oxford until then. The building was designed by John Gwynn, and the frontage consists of thirteen bays with a seven-bay pediment. (Stuart Vallis)

Clerk of the Market Weighing Butter.

There were originally two Clerks of the Market, appointed by the University to set the price of grain, and check weights, measures and prices. One of the last remaining powers at the beginning of the twentieth century was the 'Assize of Butter', when the clerks, accompanied by an inspector of police, would weigh butter that was on sale: any underweight pieces were confiscated. This happened regularly each university term. (Author's collection)

Isis Lock connects the Oxford Canal to Castle Mill Stream, a backwater of the River Thames. To the west are the railway lines and to the east the grounds of Worcester College. In the canal's eighteenth-century heyday it allowed Thames barges to access the canal's Worcester Street wharves. (Stuart Vallis)

View of Oxford from the Meadows near the gasworks. This engraving by J. Le Keux from a drawing by F. Mackenzie, and published on 1 November 1835 by J. H. Parker of Oxford, shows how the gasworks polluted the air and made a detrimental impact on the view of Oxford from the south.

bacon and cattle; the river and canal system sent malt and grain to London, and brought back sea-coal and foodstuffs. It occupied a central position on the coaching routes, with one hundred coaches a day coming through. A survey taken in 1834 revealed that 13,000 travellers stopped in the city overnight. Samuel Griffiths, the owner of the 'Angel and Star', was able to employ about one hundred people. Oxford at the beginning of the nineteenth century was prosperous, but its prosperity was mainly based on the provision of goods and services to the university, as the following table shows:

The leading businesses in Oxford 1790 and 1844:

Tailors	40	69
Bakers	31	56
Shoemakers	30	72
Grocers	27	29
Painters and Decorators	18	39
Carpenters	14	23
Drapers	12	14
Doctors	12	18
Wine and Spirit Merchants	10	16
Brewers	7	14
Printers and Bookbinders	5	30

The Mitre Inn, *c.* 1825. This engraving by J. Fisher shows the coach *Defiance*, which ran between Oxford, Henley and London in the early years of the nineteenth century. The innkeeper Tom Peake's name appears over the door in the illustration. (Author's collection)

During the early part of the nineteenth century the city began to expand, with St Ebbe's and St Clement's developed with working class housing, and terraced housing built in Jericho for those who worked at the University Press when it was relocated there in 1830, becoming a major employer.

Georgian terraces were built in Beaumont Street and St John Street, laid out in 1820 for St John's College. There were fine stone buildings in St Giles', and at the same time a combination of small-scale cottage development and more substantial villas began to appear in Summertown, turning it into a middle-class suburb. Throughout the nineteenth century at the top of the social scale were a group of prosperous townspeople, including brewers, bankers, lawyers, clothiers, and newspaper proprietors. A. W. Hall, a brewer and Member of Parliament, lived at Barton Abbey, while William Jackson of the *Oxford Journal* was also a banker and businessman. A family that exercised a prolonged influence in the city was the Morrell family from Wallingford. James Morrell (1739–1807) was the University Solicitor and Steward of St John's College, an office held by his son, grandson, and great-grandson. James's son Baker Morrell (1779–1854) married the daughter of the President of Trinity College, and his son (1811–1883) held the additional offices of Clerk to

The front range of the offices of the University Press was built in 1826–30 to designs by Daniel Robertson. It boasts a fine triumphal entrance archway with Corinthian columns, all in a late classical style. (Stuart Vallis)

Beaumont Street, an elegant street of terraced houses in the Regency style, some with fine ornamental balconies, was laid out between 1828 and 1837. It takes its name from the former Beaumont Palace, built just outside the North Gate by King Henry I. King Stephen held a council there in 1136, and Richard I, 'Coeur de Lion', was born there in 1157. (Stuart Vallis)

The Park Town Estate was laid out in 1853–55, North Oxford's first real development. The developers promised elegant villas, terraces and gardens, and the architect Samuel Lipscomb Seckham created two crescents with stone frontages in a late classical style. (Stuart Vallis)

the Paving Commission, and was a Conservative counsellor. Baker Morrell occupied the handsome stone house at No. 1 St Giles', and his successors continued to use the building. A descendant, Philip Morrell, was a Liberal MP for South Oxfordshire in the early twentieth century, marrying Ottoline, sister of the Duke of Portland, and together they entertained a wide literary and artistic circle at Garsington Manor in the 1920s and 1930s.

No. 1 St Giles, a two-bay stone-fronted house with a pedimented doorway, dates from the eighteenth century, and was occupied from 1846 by Baker Morrell. (Stuart Vallis)

Another branch of the family entered the brewing trade, building Headington Hall in 1824, and owning the Lion Brewery, in St Thomas Street, which operated until 1998. These prominent figures exercised a strong influence within the City Corporation, but social contact between town and gown remained limited, with deep social divisions remaining entrenched. The St Scholastica's Day ceremonies, which had always been contentious, were discontinued in 1825, and the mayor's humiliating oath of allegiance to the university lapsed in 1859.

Amongst the leading retail shops were a few who continued to flourish into the twentieth century, including R. J. Spiers & Son in the High Street, selling stationery, china and glass, Elliston and Cavell, the drapers in Magdalen Street, and Grimbly Hughes, the grocers in Cornmarket. Frank & Sarah-Jane Cooper began selling marmalade from their shop in the High Street, which became so popular that they built a factory in 1900 in Park End Street. Frank Cooper's Oxford Marmalade is still made and is a delicious accompaniment to toast at breakfast time.

Rowells, the jewellers of No. 115 High Street, was founded in 1797, a tangible link with the goldsmiths and silversmiths who had occupied the area around the church of All Saints since medieval times. Sadly the business closed in 2019.

The railway eventually arrived in 1844 when a branch line of the Great Western Railway was opened from Didcot, with the line to Worcester opened in 1853. The LNWR opened a line between Oxford and Bletchley in 1850, with a separate station. The city had missed

For many years Elliston and Cavell was the leading department store in Oxford, opposite the Church of St Mary Magdalene, and originally established in 1835. The original store was demolished in 1894 to make way for the current building, which was luxuriously fitted out with gold-plated taps in the ladies powder room. It was taken over by Debenhams in 1953, but they went into administration in 2020 and closed. This advertisement for the store appeared in the 1920s. (Author's collection)

Originally started as a shop selling hats and hosiery, at No. 46 High Street, Frank Cooper expanded into selling groceries and moved to Nos 83 and 84 High Street. In 1874 Frank Cooper's wife, Sarah-Jane (1848–1932), made 76 pounds of marmalade to her own recipe, which proved so popular that production moved to a purpose-built factory on Park End Street. (Stuart Vallis)

The Old Marmalade Factory was built in 1902–03 to manufacture marmalade and jams made by Frank Cooper. Designed by Herbert Quinton, it was strategically sited close to the goods yards of the Great Western Railway and LNWR. (Stuart Vallis)

out on an earlier proposal by the GWR in 1836, because of opposition from the university and local tradesmen, worried about student discipline and London competition, but the developing railway network reinforced Oxford's position as a regional centre and boosted local industry and employment, with a colony of railway workers established in Osney.

Underemployment, or only seasonal employment within the city, remained a continuing problem, because when the university was on vacation many sources of employment went into temporary abeyance. The coming of the railways caused an immediate reduction in the coaching trade, and also affected canal traffic, although certain goods such as coal, slate and pottery continued to be carried by canal barge.

While the city grew rapidly during the first half of the nineteenth century university numbers remained static. Gradually the colleges took on a formal teaching role in addition to providing accommodation, and the tutorial system was developed to provide oversight and pastoral care, as well as teaching. Over 50 per cent of Oxford undergraduates came from the gentry or the clergy, and more than 60 per cent ended up going into the church. All graduates still had to subscribe to the Thirty-Nine Articles, which restricted the potential intake to members of the Church of England.

This stable and complacent environment was shaken up from the 1830s onwards by what came to be known as the Oxford or Tractarian Movement. It all began in 1833 when Revd John Keble, rector of Hursley, Hampshire, preached the Assize Sermon at the university church of St Mary the Virgin, in which he criticised the proposals of the Irish Church Temporalities Bill introduced by the reforming Whig administration. He felt that the church was in danger of losing its spiritual independence and risked becoming

Revd John Keble (1792–1866) was one of the leaders of the Oxford Movement. He became known for his collection of poems, *The Christian Year*, published in 1827, but in July 1833 he delivered his Assize Sermon in St Mary the Virgin on 'National Apostasy', which began the religious revival known as the Oxford Movement. In 1836 he became Vicar of Hursley in Hampshire and remained there for the rest of his life. Keble College, founded in 1868, was named after him. (Author's collection)

merely an arm of the state, as well as falling victim to theological liberalism. A group of like-minded thinkers coalesced around the figure of John Henry Newman, fellow of Oriel College and vicar of St Mary the Virgin, and published a series of *Tracts for the Times*, in which they set out their case for a return to historic Christian traditions of faith and liturgy, and a renewed understanding of Anglicanism as part of the 'one holy catholic and apostolic church'. This led to accusations of Popery, and indeed several leading members of the movement including John Henry Newman did convert to Roman Catholicism.

It is difficult for us today to understand the intense passions that were stirred up by this movement, but it swept through Oxford and polarised opinion, with many fearing that the Protestant nature of the Church of England was being undermined. Such was the alarm that funds were raised to build a memorial to the Protestant martyrs, Hugh Latimer, Nicholas Ridley and Thomas Cranmer, burned to death in Oxford in October 1555, as a public response to the perceived Tractarian attacks on the Reformation. Designed by George Gilbert Scott, as a copy of one of the Eleanor Crosses, the monument was completed in 1843 and erected at the north end of the church of St Mary Magdalene.

In the wake of the Tractarian controversy, wide-ranging university reforms were introduced in the 1850s and 1870s carried through by Henry Liddell at Christ Church, Mark Pattison at Lincoln College and Benjamin Jowett at Balliol. There was still a heavy emphasis on Classics and Philosophy as the only suitable education for a gentleman, subjects thought to build character and train the mind. However, with the rapid industrialisation of the nineteenth century and the expansion of the university sector Oxford was in danger of falling behind. The teaching of science was urgently promoted, and later the German concept of research was introduced. New colleges were founded to open access to a wider range of people. Keble College, designed by William Butterfield, was built in startling red brick between 1868 and 1882 in memory of Revd John Keble. Hertford College was opened in 1874, Mansfield (Congregationalist) in 1886, and Manchester (non-denominational) in 1889.

An Association for the Higher Education of Women at Oxford was established in 1878, and women's colleges opened, Lady Margaret Hall and Somerville in 1879, St Hugh's in 1886 and St Hilda's in 1893. Although the number of women students increased, they encountered formidable opposition. There was a cap on numbers until 1927, and they were not formally awarded degrees until 1920.

With the removal of religious restrictions and the admission of women, university numbers increased. Large numbers of undergraduates moved into licensed lodgings in the suburbs, where the actions of three colleges, Christ Church, St John's and Merton, had influenced the spread of suburban development in Osney, Botley, East Oxford, the Banbury Road and Headington. The historic core of the city had ceased to be a place to live for most inhabitants, instead becoming largely a university precinct. In spite of this expansion, Oxford remained substantially unchanged at the end of the nineteenth century. Flocks of sheep still filled the narrow streets on market days, grass grew over the roadway in Broad Street during the long summer vacation, and the economy was still based on the retail and service industries which were geared to the needs of the university. As the city's MP, the brewer A. W. Hall, declared in 1890, 'the great need of Oxford is some large industry'. That need was about to be met in a totally unexpected way.

Lady Margaret Hall was founded in 1878 as a hostel for girls to be prepared for university examinations in what is now called Old Hall. The college grew to a majestic size, and has recently been enhanced by the addition of the Laetare Quadrangle, completed in 2017, the front gates flanked by classical porticoes. (Stuart Vallis)

The canal arrived in Oxford in 1790 and terminated at the canal basin where Nuffield College now stands. The Canal Offices, built in 1827–29, now form part of St Peter's College.

This stretch of the canal shows a view of the Church of St Barnabas, Jericho, built in the Italianate style at the expense of Thomas Combe, Superintendent of the Clarendon Press, to meet the spiritual needs of his workers. The area featured as the cholera-ridden slum of Beersheba in Thomas Hardy's novel *Jude the Obscure*. The church was designed by Arthur Blomfield and was finally completed by 1893. It soon established itself as a bastion of Anglo-Catholic worship. (Stuart Vallis)

The County Hall, built on New Road in the Norman style, designed by John Plowman, in 1840–41. It has a castellated porch and two turrets. The County Gaol buildings lie behind it, part of the castle. (Stuart Vallis)

Central Oxford, early twentieth century. This map shows the central area of the city as it was c. 1910. The layout of roads and open spaces remains substantially similar both to the later Middle Ages and to Oxford today. The line and station of the LNWR, now gone, can be seen on the western side of the city. (Author's collection)

Aerial view of central Oxford, twenty-first century. (Robert Lind)

Mother Goose of Oxford

During the heyday of the coaching inns in Oxford during the eighteenth century, there were many well-known personalities associated with them, not least 'Mother Goose', an elderly lady, almost blind, who used to frequent the inns with her baskets of flowers. She was usually seen at the Star Inn, later the Clarendon Hotel, but also frequented the Lamb and Flag, where the Prince Regent (King George) would fling her a guinea and take a bouquet when he was changing horses. In her younger days she had been a procuress, but later married and earned a living by flower selling. An account in *The English Spy* of 1824 describes her:

> Her ancient, clean, and neat appearance, her singular address, and, above all, the circumstance of her being blind, never failed of procuring her at least ten times the price of her posy, which was frequently doubled when she informed the young gentlemen of the generosity, benevolence, and charity of their grandfathers, fathers, or uncles, whom she knew when they were at college. She had several illegitimate children, all females, and all were sacrificed by their unnatural mother, except one, who was taken away from her at a very tender age by the child's father's parents. When of age, this child inherited her father's property, and is alleged to have become the wife of an Irish nobleman.

She is an example of the many characters associated with the coaching trade, including Mr Tilleman Bobart, Bedel in Law, who ran a four-horse coach between Oxford and London in 1815; Charles Holmes, driver of the Blenheim coach, who managed sixty-five miles a day; Bob Pointer on the 'Quicksilver' Brighton coach; and John Jobson, who for many years drove 'The Prince of Wales' between London and Birmingham. With the coming of the railways this richly entertaining cast of characters and their coaches rapidly died out. (Author's collection)

Alderman William Fletcher (1739–1826), Yarnton, Oxford

William Fletcher was a well-known eighteenth-century Oxford figure, having been an alderman and three times mayor in 1782, 1796 and 1809. He was the son of James Fletcher, a well-known Oxford bookseller, and made his fortune as a draper. He cofounded the banking house now known as 'The Old Bank' (now a hotel) on the High Street. He died on 27 December 1826 at the grand age of eighty-seven. He is chiefly remembered as an antiquary who built up a fine collection of stained glass, some of which adorns the windows of the Bodleian Library, and some is in Yarnton Church. He was also a collector of ancient carved ivory and monumental brasses. He rescued the old font of St Michael's Church and installed it at Yarnton, which had been his childhood home. The Oxford City Museum has on display a series of painted panels depicting 'The Dance of Death' copied from sixteenth century originals in the eighteenth century, which decorated the hall of his Oxford home in Broad Street opposite the Old Ashmolean Museum. He died there on 27 December 1826, but was buried, in an ancient stone coffin, at Yarnton. He was keen to revive the medieval craft of monumental brasses, and designed his own monument at Yarnton, a table tomb of grey marble with a brass effigy showing him in an alderman's gown and mantle copied from the brass of Richard Atkinson, 1574, in St Peter-in-the-East, Oxford. The inscription reads:

Yarnton! My childhood's Home!
Do Thou Receive
This parting gift —
My Dust to Thee I leave

There are drawings of the brass in the Bodleian Library dated 1804, showing the dates not yet entered, which make this one of the earliest of the memorial brasses revived in the nineteenth century. (Author's collection)

Dr Martin Routh (1755–1854), Magdalene College

One renowned Oxford scholar whose life spanned both the eighteenth and nineteenth centuries was Dr Martin Routh, President of Magdalen College from 1791 to 1854, the longest serving head of any Oxford college. Born at South Elmham in Suffolk, he studied at Queen's College, Oxford, and was ordained deacon in the Church of England in 1777. He was made a Fellow of Magdalen in 1775, and was presented with the living of Tilehurst in Berkshire in 1810, where he liked to spend his holidays. He married Eliza Blagrave, a local lady thirty-five years younger. He was sympathetic to the Oxford Movement, and John Henry Newman dedicated his book *Lectures on the Prophetical Office of the Church* (1837) to him. There were many stories told about him, and sayings of his recorded, including the famous 'Always verify your references'. He was the last of his kind to wear a wig, which was accurately copied on his memorial brass. He died in his hundredth year, having in his long life seen Dr Samuel Johnson, known the grandson of William Penn, founder of the Province of Pennsylvania, and lived into the era of steam trains, telegraphs and photography. He is commemorated by a fine memorial brass in the chapel at Magdalen College, showing him in gown, bands and wig under a canopy with shields and inscription.

The Latin inscription reads:

Here lies the body of the venerable man Martin Joseph Routh, Professor of Sacred Theology, Rector of the Parish of Tilehurst with Theale, and President of this college, who died 23rd December AD 1854 in his hundredth year, on whose soul may God have mercy. Amen.

(Author's collection)

Baker Morrell (1778–1854), St Mary Magdalene, Oxford

One family that exercised a prolonged influence in the city from the eighteenth century onwards was that of the Morrells.

James Morrell (1739–1807) was Steward of St John's College and the university solicitor. His son, Baker Morrell, was born on 21 June 1771. He married Mary Elizabeth Chapman (born 1783 in Oxford), the daughter of the President of Trinity College, Oxford, and later Vice-Chancellor, in 1801. They had six children, five sons and a daughter. Baker Morrell became a prominent Oxford lawyer and Steward of St John's College. His father had bought a tenement property on St Giles Street, and Baker in around 1820 demolished the old house and built No. 1 St Giles Street, which became the family firm's office for 175 years. It still stands today, and is part of Balliol College. The census of 1851 records Baker as aged seventy-two, describing his occupation as attorney-at-law, and living at No. 1 St Giles Street in the parish of St Mary Magdalen.

When Baker Morrell died in April 1854, he was commemorated by a memorial brass, possibly designed by George Gilbert Scott, which lies in the north aisle of St Mary Magdalen, showing him in a lawyer's gown under a canopy with shields bearing the Morrell and Chapman arms. (Author's collection)

John Henry Newman (1801–1890)

John Henry Newman was an Anglican priest who became a Roman Catholic at the height of the Oxford Movement in 1845. It was a movement, as Sheridan Gilley has pointed out, 'that was shaped not so much by its leaders but by what united them, Oxford itself.' It was their shared experience of the University of Oxford that bound the leaders of the movement, John Keble, Richard Hurrell Fronde, Edward Bouverie Pusey, and Newman himself.

Brought up in the Evangelical tradition, he studied at Trinity College and then became a Fellow of Oriel College in 1822. He was ordained, served a curacy at St Clement's Church, and then returned to Oriel, being appointed Vicar of the University Church of St Mary in 1828. After Keble preached his famous assize sermon at St Mary's on 'National Apostasy', Newman began his Tracts for the Times in which he aimed to set out the basis of doctrine and discipline within the Church of England. By the time that he established a community and church at Littlemore in 1835 he was developing his views in a more Catholic direction, and in 1842 he withdrew to Littlemore where in 1845 he was received into the Roman Catholic Church. He was ordained as a Catholic priest in Rome in 1846, and returned to England where he settled in Birmingham at the Oratory, remaining there for the rest of his life. Leaving the Church of England for Rome brought him inner peace, but also deep sorrow at the parting of friends. He had been a towering spiritual figure in Oxford, but his influence lessened when he left the city. It was left to his Anglican friends and fellow Tractarians to develop his thinking and translate it into liturgical and ecclesiological developments within the Church of England. It wasn't until Newman had been dead for a hundred years that the Oratory was finally established in Oxford, using the former Jesuit church of St Aloysius at the bottom of the Woodstock Road. Here, in the words of Fr Jerome Bertram,'Oxford's Newman has returned to take his rightful place in the Oxford of Newman.' The portrait is an engraving taken from the portrait by Sir William Ross, showing Newman as a young Fellow of Oriel College. (Wikipedia Commons)

Chapter 7

The Twentieth Century

The catalyst for the transformation of Oxford was the work of a local man, William Richard Morris (1877–1963), who started making and repairing bicycles in James Street in 1892, and then, impressed by the success of Henry Ford in America, began building motor cars at his garage in Longwall Street in 1912. His first car was the Bull-nosed Morris, assembled from bought-in components, which proved so popular that in 1913 he moved the business to the former Military Training College in Cowley, employing 300 men. By 1924 he had overtaken Ford to become Britain's biggest car manufacturer, attracting allied industries to Oxford, and in 1926 The Pressed Steel Company was established, along with Osberton Radiators. By 1930 the Cowley works was one of the most advanced in Europe, and employed 10,000 people. By 1939 Pressed Steel was turning out 100,000 car bodies every year, and Oxford, along with Coventry and Luton, had become the most prosperous town in England.

The first bicycle made by Willaim Morris in 1893 for a Mr Pilchard, the Rector of St Clement's Church, Oxford. Forty years later Lord Nuffield bought back the bicycle, which is now displayed at the Oxford Bus Museum.

75

The Morris Garage in Longwall Street in the early twentieth century. The cars were hired out by William Morris, whose father Percy can be seen on the far right of the picture. (Oxford Mail)

The company letterhead, dated 17 January 1919, showing the Longwall Street Garage and the company showrooms in Queen Street. (Oxford Mail)

A picture of the original coachbuilding and body trim workshop in the Old Military Academy at Cowley in 1913. (Oxford Mail)

William Morris, 1st Viscount Nuffield, 1877–1963. (Oxford Mail)

In the 1920s and 1930s the population grew rapidly, and thousands of new houses were built, absorbing the surrounding villages, which became dormitory suburbs. The dominance of the university within the economic life of the city was replaced by the dominance of the car industry which by 1939 had become the largest employer. There was also a comparable growth in civil service and local government workers to administer this greatly expanded population. This rapid process of industrialisation and population growth, swelled by a large influx of workers from South Wales in the 1920s and 1930s, driven by unemployment there, caused considerable strain on social relations and the city's infrastructure. The newly developed council estate at Cutteslowe gained notoriety in 1934 when the developers of an adjacent private estate built a wall to prevent council tenants from using its roads, because it was thought that many of them were previous slum dwellers. In fact most were newcomers seeking work in the newly industrialised city. The wall wasn't demolished until 1959.

The city's governance was strengthened when in 1889 Oxfordshire was made a county borough, the city boundaries were extended, and the city was organised into five wards, with the university having representation on the corporation. The decision was taken to build a new Town Hall, which was opened in 1897, designed by H. T. Hare in the

The infamous Cutteslowe Walls were built by a private developer in 1934 to separate his housing development from those on the Cutteslowe estate, because he thought his houses wouldn't sell if they were next door to what he called 'slum dwellers'. There were many protests, and although the council destroyed the walls in 1938, they were forced to reinstate them. They were finally demolished in 1959 after the council acquired all the land. The walls sparked a national debate on entrenched class divisions, which persisted for many years. (Oxford Mail)

An aerial view, taken by Arthur Hobert in the 1950s, showing the Castle Mound, St George's Tower, and the prison buildings, with the Shire Hall facing onto New Road. (Oxford Mail)

The present Town Hall was designed by Henry Hare, a local architect, and opened in 1897. It originally contained the County Courts, public library and city police station, as well as the city council offices. It replaced a building designed by Isaac Ware in 1752, which itself was built on the site of the medieval guildhall, which dated from 1292. (Stuart Vallis)

'Jacobethan' style, with a lofty hall, staircase, great hall and council chamber. The city's plate room is a fifteenth-century cellar under the building, originally part of Knap Hall.

Amongst the city's plate are the maces, three seventeenth-century silver-clad iron maces and the Great Mace made at the Restoration, 5 feet 4½ inches long, silver gilt and surmounted with a crown, orb and cross with the arms of Charles II. The mayor's Chain of Office was given in 1884, made of gold with the letters 'OXENFORD' alternating with enamelled roses. On formal occasions the mayor and aldermen wear scarlet and crimson gowns trimmed with sable.

Although the tensions between the city and the university continued to simmer throughout the nineteenth century, there was more co-operation than before 1771. By the beginning of the twentieth century relations had improved considerably, leading the photographer Henry Taunt to comment: 'the University and City work side by side harmoniously in the same Council…' But he adds: 'Yet even now, although the barriers have been broken down considerably, there is a subtle something, "a feeling that oil and water will not mix," which still exists between Gown and Town, the remnant of the long

When New College was founded in 1379, Richard II gave the land to William of Wykeham on condition that the college maintained the city walls in good repair, and charged the mayor and council with inspecting the walls every three years. The tradition has been continued ever since, and the picture shows the Lord Mayor of 1975, Councillor Bill Fagg, and his wife with the Warden of New College, Sir William Hayter, walking in procession, led by the City Mace. (Oxford Mail)

tyranny of the former over the latter.' So echoes of the old rivalry could still surface, as in 1925, remembered by Dame Lucy Sutherland, at the time a tutor at Lady Margaret Hall:

> There was a spectacle wholly 17th century in character: the corporation and the university, processing simultaneously to the cathedral for a memorial service, quickened their pace upon catching sight of each other, until, to the delight of the spectators, the two parties galloped, robes flying, to reach the cathedral door first.

The hatchet was finally buried when the 600th anniversary of St Scholastica's Day was celebrated in 1955.

A series of cholera epidemics exacerbated by poor sanitary conditions in the middle years of the nineteenth century led to the setting up of a board of health and the opening of convalescent homes such as the thirty-bed Sunnyside Home on the Manor House Estate in Headington. The Oxford County Pauper Lunatic Asylum opened in Littlemore in 1846, based on a corridor plan and was soon extended in 1847. After military service during the First World War it was renamed Littlemore Hospital, and became part of the NHS in 1948.

In 1936 a number of hospitals joined together to form the Oxford and District Joint Hospital Board, and in 1948, with the formation of the NHS, they were formed into four groups:

1) United Oxford Hospitals
2) Warneford and Park Hospitals
3) Wingfield Morris (later Nuffield) Orthopaedic Hospital
4) Littlemore and Longworth Hospitals.

2) and 4) combined in 1968 to form the Isis Group.

The Sunnyside estate in Cowley was given to the Radcliffe Infirmary in 1921 by Dr Ivy Williams, and the house was used as a convalescent home. In 1930 the estate was sold, and the name was transferred to a new thirty-bed convalescent hospital on the Manor House Estate in Headington. It closed in 1969 and the land was used for the site of the new John Radcliffe Hospital. (Oxford Mail)

The Manor House Estate in Headington was chosen for a brand-new hospital, with the maternity hospital opening in 1968 and the acute hospital in 1979, since extended. The entire complex, including the Churchill Hospital and Nuffield Orthopaedic Centre, is now the Oxford University Hospitals NHS Foundation Trust.

The city's cultural activities had tended to centre on the colleges, where the chapels were centres of musical activity. Music-making had for a number of centuries been an important social activity, but it was the visit of George Frederick Handel in 1733 that stimulated the demand for a concert room. The Holywell Music Room was opened in 1748, designed by Dr Thomas Camplin of St Edmund Hall, the oldest music room in Europe. The other chief concert halls are the Sheldonian Theatre and the Town Hall, but a brand new 500-seater concert hall is being built as part of the Stephen A. Schwarzman Centre for the Humanities in the Radcliffe Observatory Quarter, due to be opened in 2025.

The Playhouse Theatre was established in 1923, and a new theatre built on Beaumont Street in 1938 by Sir Edward Maufe, with a striking art deco interior.

The city has been well served by local newspapers. The *Oxford Journal*, begun in 1753, was the longest lasting local newspaper, closing in 1928. By that time the *Oxford Times*, first published in 1862, had been joined by the *Oxford Mail*, which first appeared in 1928. They amalgamated their evening papers the following year, and the businesses eventually

The origin of St Giles' Fair can be traced to medieval times, but the earliest reference dates from the reign of James I. It evolved from the St Giles' parish wake, first recorded in 1624, but by 1800 it had become a general fair with stalls and rides, and continues to the present day, held on the Monday and Tuesday after the Sunday following the 1 September, St Giles' Day. The photograph, dating from around 1905, shows the scene looking towards St Mary Magdalene Church. (Author's collection)

The Playhouse Theatre was founded in 1923 by Jane Ellis and Alfred Ballard, and used premises on the Woodstock Road. The current theatre building on Beaumont Street was designed by Sir Edward Maufe, and the splendid art deco interior by F. G. M. Chancellor. The building was completed in 1938. (Stuart Vallis)

This was the first Oxfam shop, established by the philanthropist Cecil Jackson-Cole (1901–1979), in 1947. The Oxford Committee for Famine Relief was founded in 1942 by a group of social activists and Oxford academics, initially to help the starving inhabitants of occupied Greece, and the shop originally distributed donated clothing. It has since developed into a national chain. (Stuart Vallis)

combined as the Oxford Mail and Times Company to produce the only daily and weekly newspaper in the city, still going strong today.

The university, as well as the city, benefited from the generosity of William Morris. Created Viscount Nuffield in 1938, he took little part in civic life, but gave large sums of money for medical and scientific research, and in 1937 to found Nuffield College. In the years after the Second World War a number of new colleges have been founded, mostly for post-graduates, including St Anthony's (1950), Linacre (1962), Wolfson (1966) and Green College (1979). St Anne's College, originally the Oxford Society for Home Students, gained collegiate status in 1952, and St Catherine's College was built to the strikingly modern designs of the Danish architect Arne Jacobsen in 1963. From 1974 onwards colleges began to become co-educational.

Oxford's rapid industrialisation and expansion in the years before and after the Second World War led to pressures on the planning process and rapidly growing traffic problems. A number of planning surveys were conducted from the 1920s onwards, including the seminal 'Oxford Replanned' of 1948 by Dr Thomas Sharp. The first green belt outside London was created in 1956, which put a brake on haphazard development outside the city, but this is now under threat because of the pressure to build new houses, driven by

Nuffield is a graduate college, founded in 1937 following a substantial donation to the university by Lord Nuffield, the industrialist and founder of Morris Motors. It is located on the site of the canal basin and coal wharfs, and was designed by Austen Harrison in the style of 'Cotswold domestic architecture', according to the wishes of Lord Nuffield. The buildings were finally completed in 1960. (Stuart Vallis)

Taken from *Towards a Plan for Oxford City* by Lawrence Dale, published in 1944, the map shows where the proposed relief road, called 'The Mall', would be built, connecting the Iffley Road with St Ebbe's and the stations on the western side of the city. (Author's collection)

the numbers of people who have to commute into the city for work from outlying towns and villages, and the lack of affordable housing in the city. The area around St Ebbe's was completely redeveloped in the 1960s to allow for new roads and car parks, and a proposal was put forward for an inner ring road bisecting Christ Church Meadow and linking east and west Oxford.

This had first been suggested by Lawrence Dale in his *Towards a Plan for Oxford City* in 1944, in which he put the case for a new road, which he called The Mall, through the bottom of Christ Church Meadow to reduce traffic congestion at Carfax, The Plain and the High Street. The industrial development of the city had taken place on the east side, remote from the railway stations which were on the west side and in his analysis of the pressures this produced Dale identified four zones:

1. The light industry, gasworks, goods yards, and markets astride the railway and canal.
2. The retail trading and amusements astride Cornmarket.
3. The university astride the High Street and Broad Street.
4. The industrial complexes in Cowley to the east.

Dale stated that the only way to relieve traffic passing through High Street and Carfax and to allow traffic to pass easily between these zones was to build a supplementary

road, and that only the north bank of the Thames provided what was needed. Thankfully this proposal was never implemented, although there was general agreement on five points: the need to control growth, the provision of more services for the Cowley area, the completion of the ring road (begun in 1932 and completed in 1965), the restriction of traffic in the city centre, and the building of other inner relief roads.

In spite of measures such as traffic restrictions and the building of park and ride terminals around the Ring Road, traffic congestion and controls remain a contentious issue. The current Central Oxfordshire Travel Plan has proposed a set of initiatives including traffic filters, low traffic neighbourhoods, zero emission zones, and workplace parking levies to improve air quality, cut emissions and create safer routes for cyclists and pedestrians. These proposals remain controversial, and their likely impact on the vibrancy of the city centre and its viability as a retail destination is unknown.

Today modern buildings predominate in Cornmarket, George Street and Queen Street, while the High Street, Broad Street and St Aldates retain many older properties. The Westgate Shopping Centre, built between 1969 and 1972 in St Ebbe's, was completely rebuilt between 2016 and 2017 as a major retail and leisure complex, and Gloucester Green, site of the former cattle market, has been redeveloped as a complex of buildings with a market square and the city bus station. The Castle, which became the town gaol, with a new prison built in 1786, altered in 1819–20, and enlarged and remodelled by J. C. Buckler between 1851 and 1856, is now part tourist experience and part modern hotel.

This aerial view, taken from the north-west in the 1980s, shows Oxford station in the foreground. The former tracks of the LNWR can clearly be seen, most of the area turned into a car park. The Old Marmalade Factory is top centre, and the terraced houses of Abbey Road, Cripley Road and Mill Street at bottom right, with the River Thames in the bottom right corner. (Oxford Mail)

Having had a mayor since the early thirteenth century, on 23 October 1962 the city was granted the honour of electing a Lord Mayor. The picture shows the Letters Patent of HM the Queen, which raised the status of the city's chief magistrate to Lord Mayor. The seal shows on the obverse Queen Elizabeth II on horseback, and on the reverse the Queen enthroned, crowned and with orb and sceptre. (Oxford Mail)

By the immediate post-war years the fabric of Oxford's unrivalled collection of historic buildings was in a sorry state, ravaged and blackened by the smoke from the thousands of coal fires in colleges and private houses. A major cleaning and restoration programme began with the establishment in 1957 of the Oxford Historic Buildings Fund. The conservation of city centre buildings was further supported by the Oxford Preservation Trust and the Oxford Civic Society, which have helped to raise public awareness of the built environment and the importance of commissioning good modern architecture, as well as preserving the old.

Oxford has seen a continuous process of change and development, from small Saxon burh to thriving medieval market town, the 'Christminster' of Thomas Hardy's *Jude the Obscure*, the transformation of the centre with the fine university buildings of the seventeenth and eighteenth centuries, the explosion of what John Betjeman called Motopolis, and the unplanned expansion of the suburbs as a result of the motor industry. At its peak in the 1970s the motor industry employed 28,500 people but it has seen considerable decline since then, and the BMW Mini Plant now employs about 5,000 people. Education has taken over, once again, as the largest employer in the city. The Oxford Technical College, founded in 1955, gained Polytechnic status in 1970, and became Oxford Brookes University in 1992. The two universities employ more than 21,000 people and educate over 40,000 students.

As a result of two commissions, the first by Lord Franks and the second by Sir Peter North, Oxford University adapted its governance structures to meet current demands, with Congregation remaining the legislative body, and colleges remaining the heart of the university. This tradition of proud self-government provides a tangible link to the medieval past, but is again under scrutiny by the Charity Commission because of perceived conflicts of interest within these ancient structures. Over recent years there has been considerable investment in new residential buildings, libraries and sporting facilities, and great efforts have been made to broaden the social intake and encourage

Oriel College Front Quad. This late nineteenth-century photograph shows the ravages of environmental pollution on the stonework of many historic buildings in the centre of Oxford. The decay was the result of centuries of smoke damage from the many household fires in the city. The Oxford Preservation Trust was founded in 1927 to tackle this crisis, and Oxford's buildings are now in much better condition. (Author's collection)

This pen and ink drawing by Edward Bawden appeared in *The D.I.A. Cautionary Guide to Oxford* (Design and Industries Association: 1930). The book was a mostly negative assessment of building development in Oxford at the time, and the vignette shows a modern advertising hoarding against a background of the towers and spires of Oxford. (Author's collection)

The vast British Leyland and Pressed Steel car works in Cowley. In 1986 it was renamed The Rover Group, and later went into partnership with Honda, but in 1994 the group was sold to BMW, which moved Rover production to Longbridge and retained the Cowley plant to build the new Mini, which it continues to do today. The picture shows the plant as it was in 1992. (Oxford Mail)

The Lord Mayor for 1982–83 was Revd Canon Tony Williamson, a worker-priest and Leader of the Labour Group on the City Council. He was the first Anglican priest to be ordained while in factory work, and later became Director of Education for the Diocese of Oxford. He was appointed OBE in 1977. Here he is presenting the proceeds of a sponsored swim organised by the Rotary Club to numerous recipients at the Town Hall. (Oxford Mail)

more state school pupils to apply. There has also been a rapid increase in the number of post-graduate students, many from overseas, and this multi-cultural mix is reflected in the wider city, with the growth of flourishing Muslim, Hindu, Sikh and Buddhist communities. Oxford's inclusivity and diversity is reflected in the appointment of the university's first female Vice-Chancellor in 2016 (her successor is also female), and the election as Lord Mayor for 2023/4 of Councillor Lubna Arshad, the youngest ever Lord Mayor, the first woman of colour and the first Muslim woman to hold the position.

Revd Montague Henry Noel (d. 1929), St Barnabas, Jericho

The Oxford University Press, first set up in the fifteenth century, was established in its present impressive building in Walton Street in 1830. The business expanded greatly and soon the area known as Jericho was being filled with workers' houses for those employed at the canal wharves, the Eagle Ironworks, and the University Press. Thomas Combe, who had become the University Printer in 1830, felt there was a need for a new church to serve the spiritual needs of his workers. As an ardent supporter of the Tractarian Movement and the subsequent ritual revival, Combe commissioned the architect Arthur Blomfield to design a building in the Italian Basilica style, which was consecrated in 1869. The first vicar of the parish was the Revd Montague Henry Noel, who served there for thirty years. He and Combe were determined that the church should stand firmly within the Catholic tradition of the Church of England.

Thomas Hardy described the church in *Jude the Obscure* as St Silas, 'the church of ceremonies', with its fumes of incense which clung to the clothes of the congregation. Hardy was a pupil in the office of the architect Blomfield in the early 1860s.

Francis Kilvert was in Oxford on Ascension Day 1876 and described the ceremonies in his diary in disparaging terms, speaking of the celebrant as 'the emaciated ghost in the black biretta and golden chasuble', who may well have been Noel himself.

He became a much-loved and respected Oxford clergyman, and many stories are told about him. His skill as an amateur dentist was well-known throughout Oxford. One account states:

> In his middle life Father Noel developed a hobby for tooth extracting. He procured a set or two of forceps, and for a good many years was the principal dentist for the parish, not only for boys and young girls, but for many adults too.

Many who feared a dentist would not object to have a tooth out unofficially. It was wonderful too what luck he had. Almost invariably the extraction was a successful one, and I have never heard of any complication arising afterwards.

He suffered from ill health in his later years, and died on 29 October 1929. He is commemorated in St Barnabas by a fine memorial brass, showing him in mass vestments and holding a chalice, all based on items still in use today. (Author's collection)

William Richard Morris (1877–1963), 1st Viscount Nuffield

William Morris was an entrepreneurial businessman who was to exercise an enormous influence over the development of Oxford in the first half of the twentieth century, and to become one of the city's major benefactors.

He was born in Worcester and moved to Oxford when he was three years old. He left school at fifteen, and was apprenticed to a local bicycle seller and repairer. A year later he set up his own business repairing bicycles, opened a shop on the High Street, and began selling his own product, 'The Morris'. He expanded into motorcycles, and then acquired premises in Longwall Street where he repaired bicycles, and sold and hired out cars. His Longwall Garage survives today as student accommodation for New College.

In 1912 he designed the 'Bullnose' Morris car using bought-in components, and moved his factory to a disused military training college at Cowley. After the First World War he bought out Wolseley Motors, as well as a number of other component companies, and launched the Morris Minor and MG Midget cars. He was made Viscount Nuffield in 1938, and after the Second World War merged Morris Motors with the Austin Motor Company in 1952 to form the British Motor Corporation, and retired, aged seventy-five, as chairman the same year. He gave away a large part of his fortune to charitable causes, both in the city and university, founding Nuffield College in 1937, distributing the iron lungs made in his factory across the Empire, and creating the Nuffield Foundation in 1943 to advance education and Social Welfare. His Oxfordshire home, Nuffield Place, originally gifted to Nuffield College, is now in the care of the National Trust and open to the public on a regular basis. (Oxford Mail)

Dame Louise Richardson, Vice-Chancellor, 2015–2022

Louise Richardson became the first female Vice-Chancellor of the University of Oxford when she took up the post in January 2016. She was born in Tramore, County Waterford, and studied for her degree at Trinity College, Dublin. She was active in the anti-apartheid movement, and during her time as Assistant Professor at Harvard University she focused on international security and terrorism, writing several books on the subject. In 2009 she became Principal of the University of St Andrews, and Professor of International Relations. Her tenure as Vice-Chancellor resulted in considerable private and government funding, the raising of St Andrew's profile, and the expansion of the university.

In 2015 she was nominated as the next Vice-Chancellor of the University of Oxford, and her tenure has again been marked by successful fundraising campaigns, the broadening of access to the university, the robust defence of free speech, and most recently the co-ordination of an emergency research programme to create the Oxford AstraZeneca vaccine to combat the Covid-19 pandemic. In October 2022 *Times Higher Education* released its annual World University Ranking, showing that Oxford had been top of the rankings for seven years, coinciding with Louise Richardson's seven years as Vice-Chancellor. In the same year she was appointed a Dame in the Birthday Honours list. (Wikipedia Commons)

Councillor Lubna Arshad, Lord Mayor of Oxford, 2023–24

On 17 May 2023 Councillor Lubna Arshad was sworn in as the new Lord Mayor of Oxford in the Town Hall. She is the youngest person to hold the post, the first woman of colour and the first Mūslim woman to hold the ceremonial position, a sign of the multicultural and ethnically diverse nature of the modern city. She was born and raised in Oxford, took her degree at Manchester, and has worked in the IT industry. She was elected a city councillor in 2018 and later represented Temple Cowley. She has been an advocate for initiatives to close the gender pay gap and to protect religious freedoms. She is a volunteer for Oxford Community Action, and amongst her chosen charities is Asylum Welcome, which provides practical help for refugees from Afghanistan, Ukraine, Syria, Iraq, Pakistan and elsewhere. She joins an unbroken line of Mayors, dating from the first recorded holder of the office, Laurence Kepeharme, 1205–1209. (Oxford Mail)

Chapter 8

The Future

The city of Oxford, like the university, has managed to be at once ancient and arcane, and yet also modern and progressive. The university remains a vibrant and successful modern research institution, while the city continues to evolve as an industrial, commercial and administrative centre, and one of Britain's technology hubs. Oxford gained worldwide recognition in 2020–21 when its Jenner Institute and the Oxford Vaccine Group developed an effective vaccine in the fight against Covid-19, saving 6.3 million lives in the first year of its global rollout.

This aerial view of the curving sweep of the High Street was taken in 1961, and shows the view from the south-east, with Magdalen College at the bottom right, the dome of the Radcliffe Camera in the middle and Christ Church Meadows on the left. (Oxford Mail)

Matthew Arnold's 'Beautiful city! So venerable, so lovely, so serene' has shown itself to be remarkably resilient and adaptable over the 1,500 years and more of its existence, able to live with its many contradictions, and with the intellectual and entrepreneurial energy to keep reinventing itself to keep pace with society's changing needs. It has been described as a place with large-city characteristics but small-city geography, and therein lie many of the challenges for the future. It has established itself in recent years as a global scientific powerhouse, the centre of a network of science parks and campuses which stretch as far as Milton, Culham and Harwell, with nearly 3,000 high-tech businesses in the region. With its precious concentration of beautiful buildings, its economic vibrancy, entrepreneurial spirit, its academic excellence and its rich mythology, it surely has the resources to enable it to flourish into the third millennium.

Beaumont Street at night. (Stuart Vallis)

Oxford Timeline

4000–800 BC	Monumental ritual earthworks are built on the Oxford gravel terrace, with isolated burials on hills around Oxford.
800 BC–AD 42	Scattered farmsteads appear.
AD 43–400	Pottery manufacturing in east Oxford. Scattered Roman settlements.
AD 400–750	Rural settlements are established, and Frideswide founds an oratory at Binsey and a nunnery at a crossing point of the River Thames.
AD 750–1066 AD	A trading centre develops by the crossing point, and Oxford is established as a Saxon burh, or fortified settlement, with a rectilinear street plan centred on Carfax. Edward the Elder, King of Wessex, fortifies the site. The earliest extant buildings, St Michael at the North Gate Tower and St George's Tower, date from this period.
AD 1066–1200	After the Norman Conquest, in 1071 a motte and bailey castle is built at the western end of the town. New churches, priories, Osney Abbey and the Grandpont causeway are constructed. A royal residence, Beaumont Palace, was built *c.* 1130. The (first) Shrine of St Frideswide is built (1180), and her cult is established. The university begins to establish itself in the twelfth century.
AD 1200–1540	Monks and friars are attracted to Oxford and establish premises. The Jewish community is persecuted, and eventually expelled. The walls are rebuilt in the thirteenth century. The town suffers as a result of the Black Death and the economy shrinks. There is an expansion of academic halls and colleges, and in 1427 the Divinity School is built.
AD 1540–1642	The dissolution of the friaries and abbeys. Henry VIII establishes a cathedral first at Osney Abbey and then at Christ Church. Oxford grows in prosperity and becomes an important staging post for the coaching trade.
AD 1642–1646	Oxford becomes the Royalist headquarters and centre of government during the Civil War. Defensive earthworks are built around the city. There is a major fire in the western part of the city in 1644.

AD 1660–1771	Extensive rebuilding of the city, with fine new buildings erected, including the Sheldonian Theatre.
AD 1771–1900	The Paving Commission was the first attempt at modern town planning. Obstructions were cleared, new drains laid and the Covered Market was built. The canal reaches Oxford in 1790. Georgian terraces built in Beaumont Street, the suburbs begin to extend into north Oxford, Botley, Osney and Headington. Women's Colleges were established, beginning with Somerville and Lady Margaret Hall in 1879. The New Town Hall was built in 1897.
AD 1900–2000	William Morris establishes his motor manufacturing business in 1912. By the 1930s the Cowley works becomes the largest employer in Oxford. Nuffield College was founded in 1937, and other new colleges followed. An inner relief road through Christ Church Meadow was proposed in 1944, but never built. St Ebbe's was completely redeveloped in 1960s. In 1934 the infamous Cutteslowe walls were built, and finally demolished in 1959. The expansion of Higher Education led to the creation of Oxford Brookes University in 1992. Education is once again the largest employer in the city.
AD 2000–2025	Oxford develops as a thriving multicultural city and in 2023 elects its first Muslim woman of colour as Lord Mayor. The Oxford Vaccine Group develops an effective vaccine to combat Covid-19 in 2020, a sign that Oxford is becoming the centre of a rapidly expanding network of science parks and campuses.